PAINTING WILDLIFE WITH JOHN SEEREY-LESTER

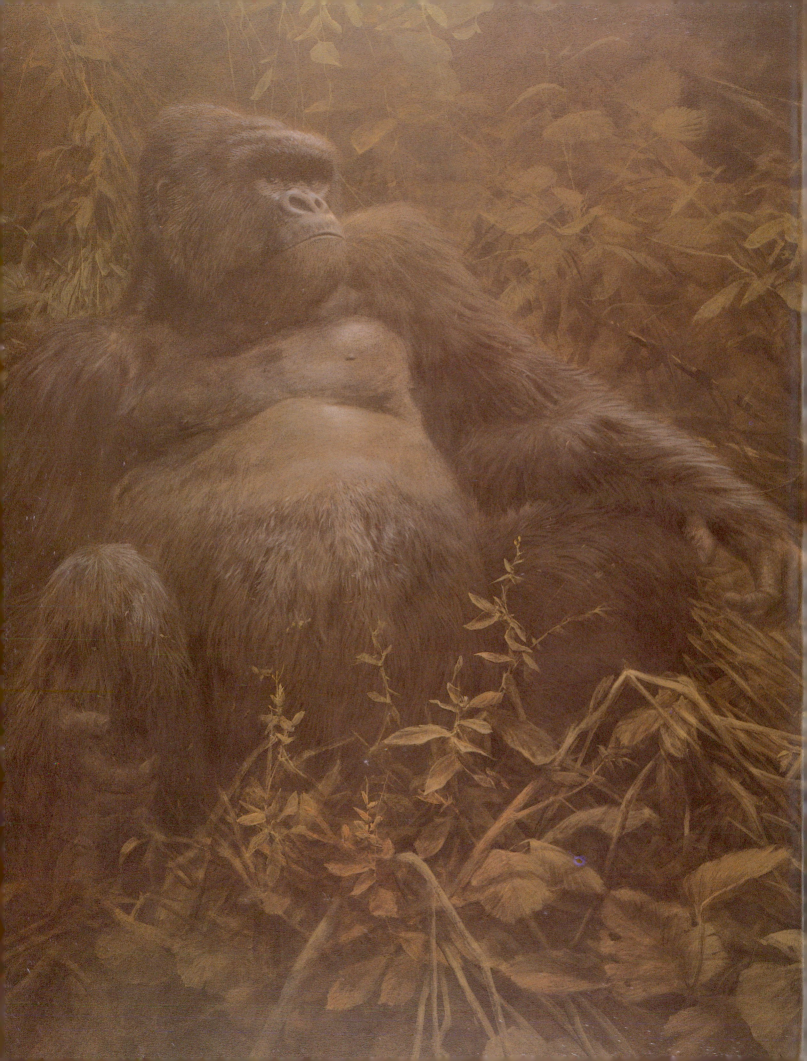

PAINTING *Wildlife* WITH JOHN SEEREY-LESTER

NORTH LIGHT BOOKS
CINCINNATI, OHIO
www.artistsnetwork.com

DARK PRESENCE
7' × 6' (2⅓m × 1⅘m) | Acrylic on canvas | 1995

painting on page 2

METRIC CONVERSION CHART

to convert	to	multiply by
Inches	Centimeters	2.54
Centimeters	Inches	0.4
Feet	Centimeters	30.5
Centimeters	Feet	0.03
Yards	Meters	0.9
Meters	Yards	1.1
Sq. Inches	Sq. Centimeters	6.45
Sq. Centimeters	Sq. Inches	0.16
Sq. Feet	Sq. Meters	0.09
Sq. Meters	Sq. Feet	10.8
Sq. Yards	Sq. Meters	0.8
Sq. Meters	Sq. Yards	1.2
Pounds	Kilograms	0.45
Kilograms	Pounds	2.2
Ounces	Grams	28.3
Grams	Ounces	0.035

Other fine North Light Books are available from your local bookstore, art supply store
or direct from the publisher.

07 06 05 04 03 5 4 3 2 1

Library of Congress Cataloging in Publication Data

Seerey-Lester, John
 Painting wildlife with John Seerey-Lester.— 1st ed.
 p. cm.
 Includes index.
 ISBN 1-58180-242-0 (hc. : alk. paper)
 1. Wildlife painting—Technique. I. Title.

ND1380 .S434 2003
751.45'432—dc21 2002029504

Editors: Marilyn Daiker and Amanda Metcalf
Designer: Wendy Dunning
Production artist: Rebecca Blowers
Production coordinator: Mark Griffin

DEDICATION

To the loving memory of my mother, Dorothy Seerey-Lester,

my guiding light—may I continue to find the way.

ABOUT THE AUTHOR

World-renowned artist John Seerey-Lester was born in 1945 in Manchester, England, where he grew up with a sketchbook in hand. He received his first commission at the early age of 13. Known for his figurative work, John began painting images of the natural world in 1980 after his first trip to East Africa. In 1982 John moved to the United States. The following year he signed with Mill Pond Press, which has published some three hundred limited edition Seerey-Lester prints.

John has traveled to Canada, Alaska, China, Africa, Antarctica, South and Central America, India and Nepal in search of the magnificent wildlife he portrays on canvas. In 1991 Mill Pond Press published and released a book on his life and work, *Face to Face with Nature: The Art of John Seerey-Lester*.

The Leigh Yawkey Woodson Art Museum, Wildlife Experience Museum, Bennington Center for the Arts and England's Nature in Art Museum include his work in their collections. His work has appeared in the Leigh Yawkey Woodson Art Museum's *Birds in Art* exhibit for many years and in the Gilcrease Museum and National Museum of Wildlife Art.

John taught his techniques to background artists and animators for Walt Disney Productions' *Mulan*. His work appeared on the cover of *Wildlife Painting Techniques of Modern Masters* (Watson-Guptill), and he has contributed to many other wildlife art books. John married fellow wildlife artist Suzie Zimos in January 2000. They live in Florida.

ACKNOWLEDGMENTS

Thanks to Open Box M, Don Andrews of Hughes Easels, Inc., Mill Pond Press and Jack Perkins. Thanks to Michael Woodward, Suzie Seerey-Lester and Kevin Schafer, Norman Lightfoot and Peter Foe of Fotoworks for photography.

Special thanks to my wife, Suzie, for all her support and help in completing this book; my son, John, for inspirational ideas and critiques over the years; Marilyn Daiker for all her patience and guidance in the preparation of the manuscript, Amanda Metcalf for shepherding the manuscript through production; Wendy Dunning for designing this book and Mark Griffin for coordinating its production and printing.

FINDING THE WAY—TURTLE HATCHLINGS
36" × 12" (91cm × 30cm) | Acrylic on Masonite | 1997

Table of Contents

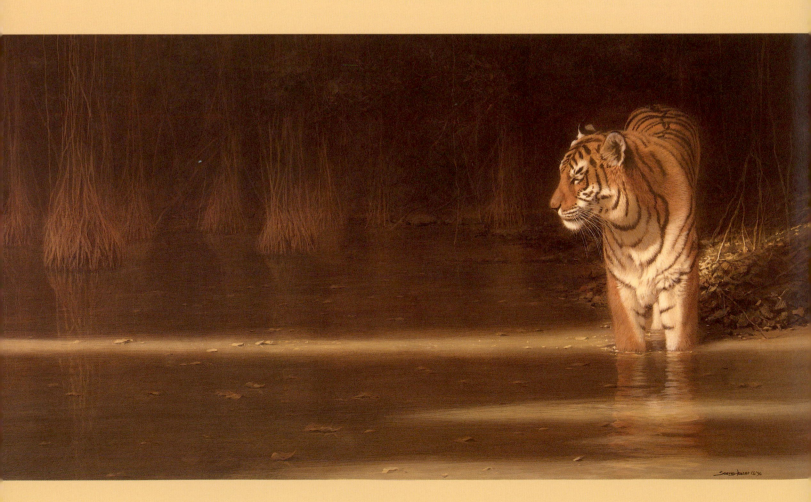

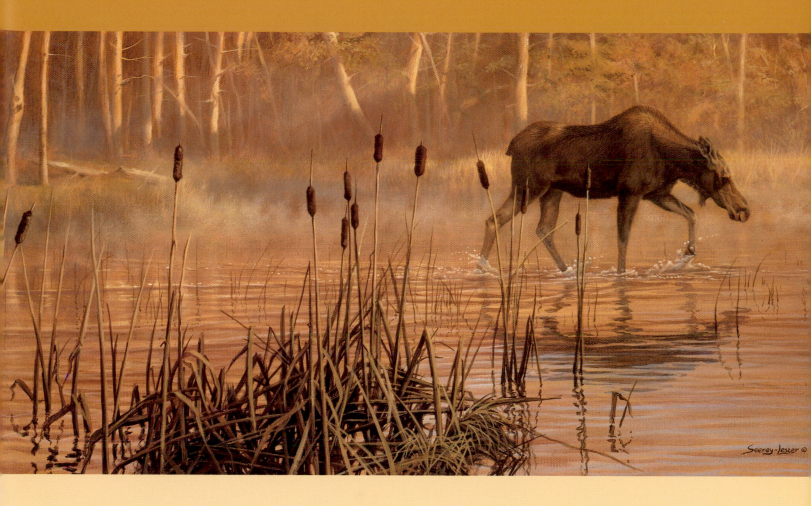

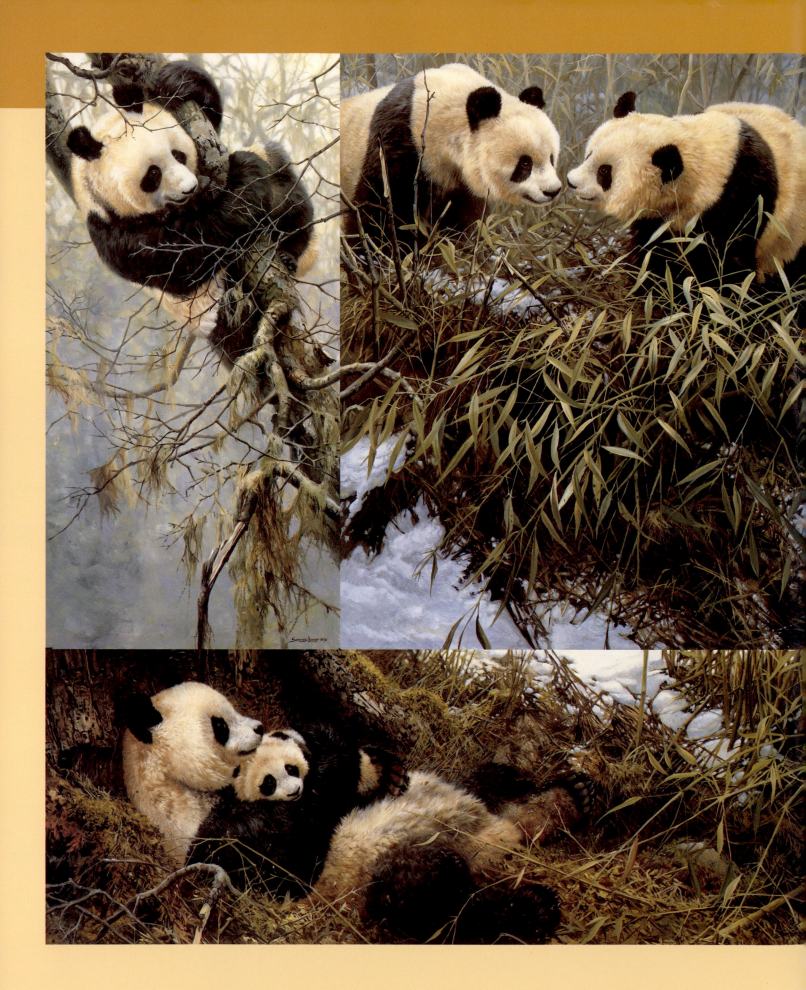

John Seerey-Lester (left) with renowned photographer, poet and broadcaster Jack Perkins

CHINA SONG
36" × 18" (91cm × 46cm) | Oil on Masonite | 1991

IN HARMONY
36" × 30" (91cm × 76cm) | Oil on Masonite | 1991

FUTURE SONG
18" × 48" (46cm × 122cm) | Oil on Masonite | 1991

THE WILD SIDE OF LIFE

Let me tell you a secret about John Seerey-Lester. A secret even he may not know.

As his friend and neighbor, I have noticed that wherever I find John—at his easel, painstakingly working and re-working his latest, and thus most important creation with the careful skills of decades of training and practice; or of an evening, dining with friends al fresco under the canopy of stars at his beachside home; or, heck, at dawn in his robe hauling trash cans out to the curb—wherever I find him, it seems to me he is not really there!

I don't know where he is, but I suppose he's back in camp in Africa, he and Suzie rising at three thirty in the morning to be waiting with sketch pads when the animals begin stirring for the day. Or on the snow plains of Alaska with a bear before them and a majestic eagle overhead. Or in China, peering into a bamboo thicket to greet an adorable panda.

Adorable. That word is the key. To John, all wildlife is adorable, meant to be adored. Through his continual travels, he puts himself in position to adore firsthand. For those who cannot go where John goes, his inspirited paintings allow us to adore as well.

I hesitate here. The first definition my dictionary gives for adore is "to worship as God or a god." Does John consider the charging tiger a god? No. He goes to church to worship God. He goes to the wild to pay homage to the multifold creatures God has placed there. Maybe that, too, is a form of worship. If so, how reverently John Seerey-Lester preaches to us all.

If he is one of the most accomplished and renowned wildlife artists in the world (and he is), he seems to know all the others. To his Florida home on visits come such as the great Belgian artist, Carl Brenders, and the Canadian master, Robert Bateman. These colleagues, though they work apart, share so much: Their fame and success, of course, but more, their dedication to life. It is the majesty of life, in whatever species it be manifested, that impels their creativity.

To his studio also come eager students; John teaches patiently. He cofounded a group to convert an abandoned water tank into a workshop where he and others could provide free art instruction to children who might otherwise have no such chance.

As he mentions later in these pages, his two-car garage is filled not with cars but with canvases, paintings that didn't quite make it, that may someday, but not yet. He knows what is right; he knows what isn't; he knows how to make it right. That is the definition of Master.

Of course, he makes money from his art, but that is not why he does it. He does it for love. He is a professional to be sure, but by the purest definition, John Seerey-Lester is the consummate amateur.

—Jack Perkins

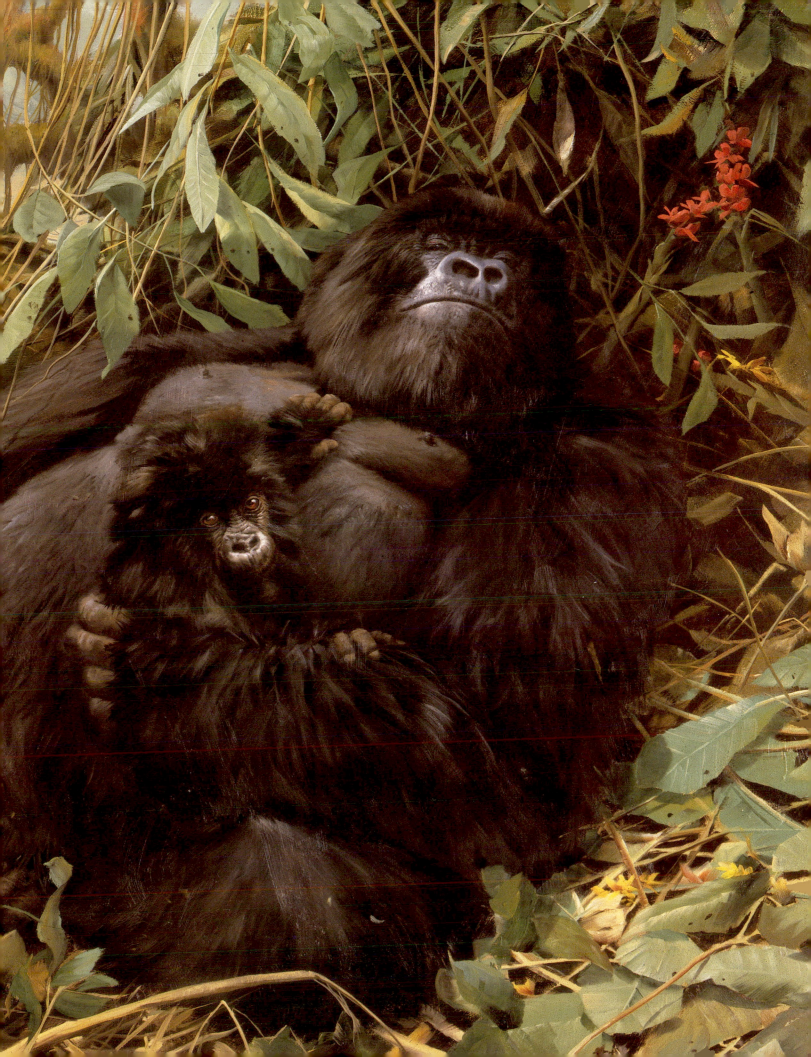

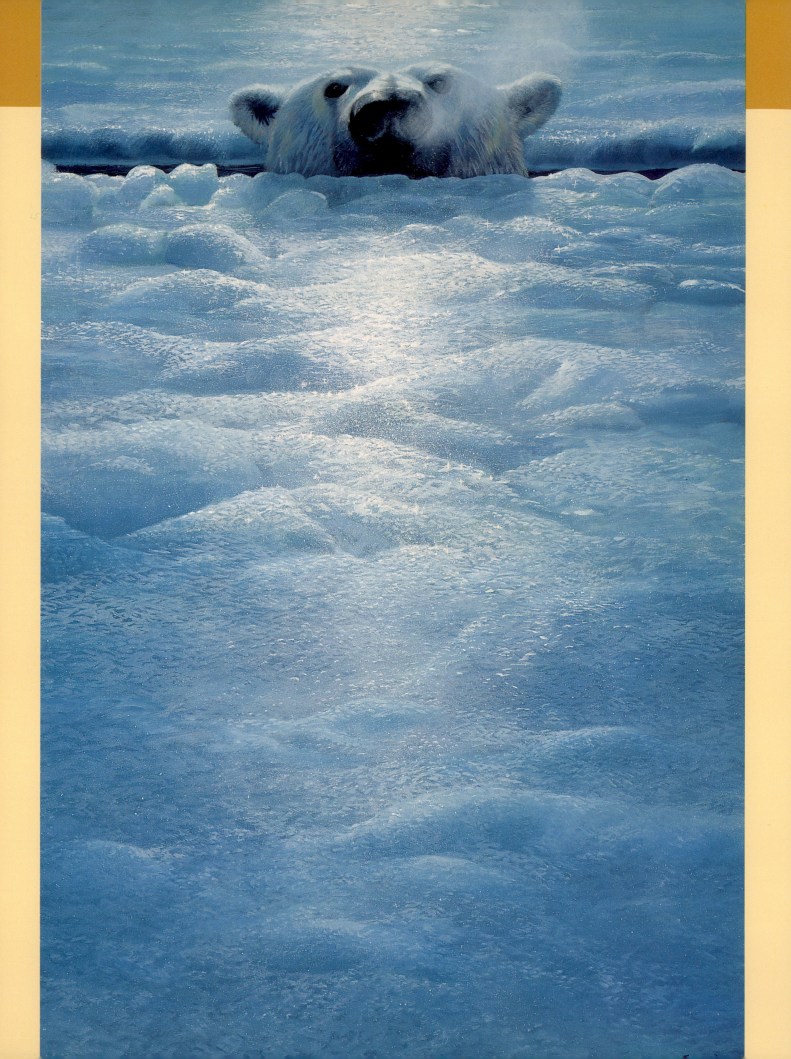

Why and How I Paint

I've had a passion for painting since I was a young boy. At one time I painted portraits, nostalgic scenes and people on the streets of Manchester, England: a different form of wildlife! Now I paint the wildlife of nature. Through my love of nature and the environment, I try to convey my passion in paintings so the viewer can share the experiences I've had. I've been chased by grizzly bears and I've encountered wolves, gorillas, tigers and pandas firsthand. A painting is more than a rendition of an animal or bird; it needs other elements to capture the viewer's interest. To make a painting interesting and exciting with a good composition, you have to allow the viewer's eye to go beyond the boundary of your surface. Imagine your painting as a window to the world, and let the viewer experience the entire world, not just the part you can see through the window.

FOCUS ON THE SUBJECT
I placed the main subject, the polar bear, at the top of the painting looking out from a hole in the ice. I used the arctic moonlight to focus on the bear and frozen snow. I added the misty breath to provide the viewer with an idea of how cold this scene is. I used several colors, mainly a mixture of Alizarin Crimson, Viridian, Ultramarine Blue and Titanium White.

POLAR LOOKOUT
48" × 36" (122cm × 91cm) | Oil on canvas | 2000

Working From the Abstract

The inspiration for most of my paintings comes from my background in abstract art, which I studied in college. I think in terms of concepts instead of setting out to paint a cougar or a grizzly. After studying potential subjects and their habitats in the field, I return to the studio with my field sketches and decide how to present the subject. I create an abstract idea for the design and composition first, then choose the species that suits that composition from my sketches. For *Loonlight* on page 15, I used an abstract image I had done years earlier, a solid black square with a white ball and a white straight line. In this case, I chose loons as the main subject and painted them in moonlight. The white ball became the moon's reflection in the water. The line became the wake of the loons as they swam past.

FORM ABSTRACT DESIGN CONCEPT
I frequently base compositions on abstract shapes. I often transform an idea from an old abstract painting into a realistic wildlife painting.

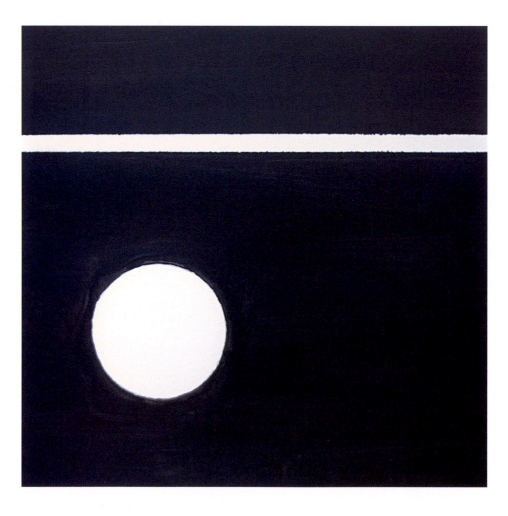

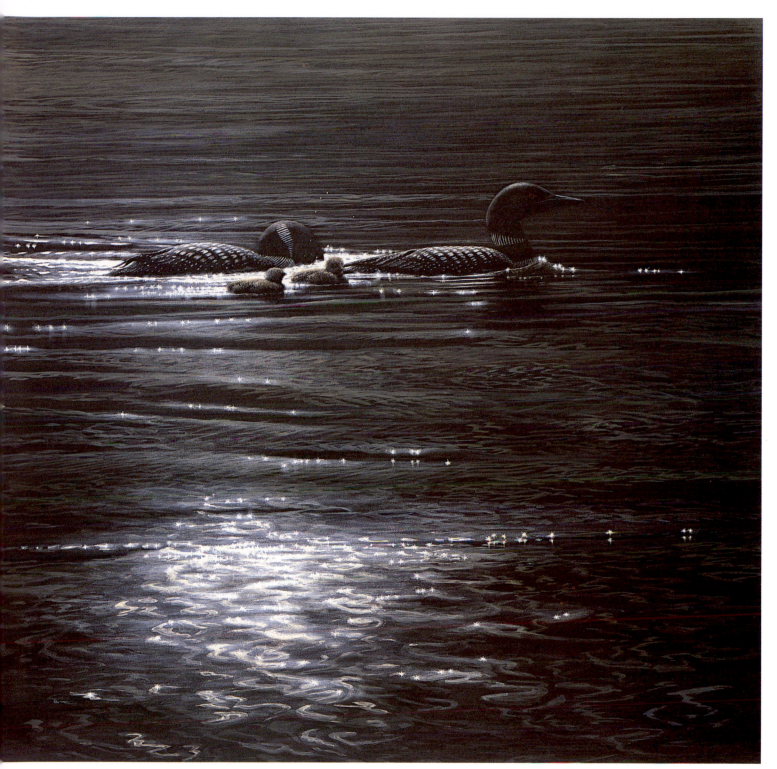

BASE PAINTING ON ABSTRACT DESIGN

This painting is based on the abstract design on page 14. I used few colors for the whole painting. I premixed equal amounts of Burnt Umber, Payne's Gray and Ultramarine Blue and applied this mixture in a series of washes until I got the desired dark. Then I added a mixture of gesso with a touch of Naples Yellow for the highlight areas, including the loons' plumage.

LOONLIGHT
36" × 36" (91cm × 91cm) | Acrylic on Masonite |
1992

15

Getting Started

I use the same colors whether painting with Rembrandt Artist Quality oils or Winsor & Newton Finity acrylics: Ultramarine Blue, Burnt Umber, Payne's Gray, Cobalt Blue, Burnt Sienna, Raw Sienna, Yellow Ochre, Naples Yellow, Titanium White and Portrait Pink or Flesh Tint. For acrylic painting I also use white gesso and occasionally Cadmium Yellow and Cadmium Red. For oil painting I add Alizarin Crimson and Viridian to my palette.

PRIME WITH MID-GRAY GESSO MIXTURE

Before I start an oil or acrylic painting, I prime my panel or canvas with a mid-gray mixture of equal parts of acrylic Ultramarine Blue, Payne's Gray, Burnt Umber and enough white gesso to get a value I like. You also can add Burnt Sienna to the mix to give the background a warm earth tone. Starting with the midtone gray surface allows you to assess early on how the dark and light colors will work in your painting. When you start with a white background, you have to constantly fight to cover the white.

MY PALETTE

Place a glass palette over a piece of Masonite painted with the same midtone gray so you can see the colors as they will appear in your painting.

Brushes

I use flat brushes for about 95 percent of my painting. For acrylics I use Pro Arte series 106 flats from ⅜-inch (10mm) to 1¼-inch (31mm) and a series 103 liner. Winsor & Newton's Cotman series 666 or Robert Simmons series 21 also work well. For oils I use Langnickel Royal sable series 5590 flats nos. 2, 4, 8, 16 and 30 and occasionally nos. 10, 12 and 44. I also use Winsor & Newton Galleria brushes and a Robert Simmons no. 2 series 750 liner. I also use house-painting brushes for glazes and washes covering large areas. For example, I like to layer washes over the entire surface during a painting to establish color and depth.

MY BRUSHES

I use (clockwise from bottom left) Pro Arte flat brushes and liners for acrylic painting, Winsor & Newton Galleria flats and Langnickel flats for oil painting, house-painting brushes for washes and glazes and a Robert Simmons liner.

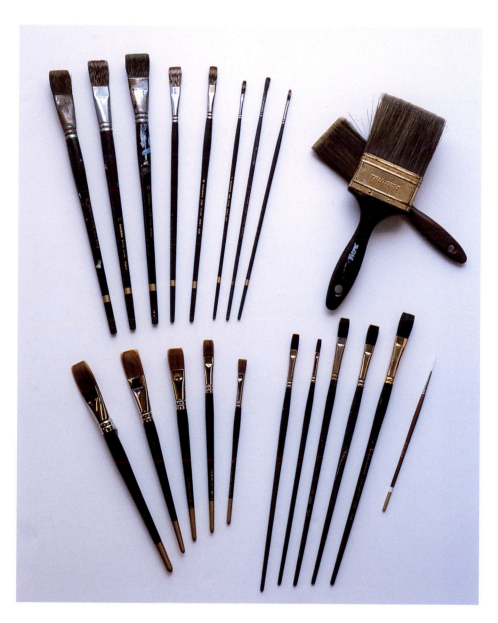

Studio Equipment

Equipment is a very personal thing, and each artist has his or her personal preferences. I use the Hughes easel no. 3000, which allows you to adjust the position of the painting instead of your own position. I sit on a high-backed office chair with wheels and arm-rests, and my glass palette sits on top of a wheeled table to my right, so I can move freely when working on a painting of any size.

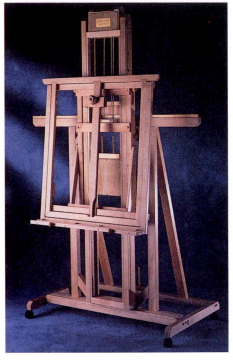

MY EASEL
Through a system of counterbalances, you can move a painting of any size either vertically or horizontally with your fingertip. I've even used the Hughes easel for 7' × 8' (2m × 2⅖m) canvases with no problem.

Field Equipment

In the field, I use Open Box M Pochade boxes, which come in various sizes to hold panels from 6" × 8" (15cm × 20cm) to 12" × 16" (30cm × 41cm). I also use a French easel. I often use a lap box to carry acrylics and a Cotman box for watercolors. I also bring along a palm box to hold 6" × 8" (15cm × 20cm) panels. I can hold it in my hand or place it on a tripod. To get a close-up view for my study, I use a Kowa model TSN-1 spotting scope with a 30X wide-angle eyepiece and Leica power 7X35 binoculars. For long sessions, I use a folding chair with a back. For shorter sessions I bring a smaller stool that's easier to carry. And of course, I bring along a hat for protection from the weather, whether it be sun or rain.

Half and full French easels Pochade box on a tripod Spotting scope on a tripod Sketchbook Binoculars

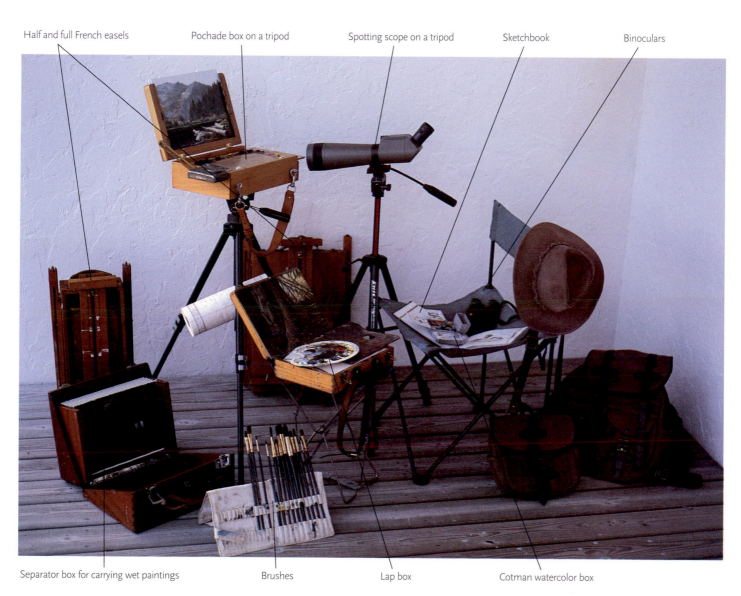

Separator box for carrying wet paintings Brushes Lap box Cotman watercolor box

Preliminary Sketching

It's a good idea to do preliminary sketches before starting the main piece, but I also often like to create as I go along on. Don't be afraid to change the image while you're working on it. It's an exciting way to create. Of course, it doesn't always work, and I have a garage full of paintings to prove it!

EXPERIMENT

When I conceived this painting, I envisioned the young leopard high in a tree, looking through the leaves. Painting on top of my usual mid-gray primer, I used backlighting to add drama and enhance the composition. Once complete I realized this approach just didn't work. So, using my gray primer, I painted out the leaves, background and foreground, leaving portions of the tree branch and the cat itself.

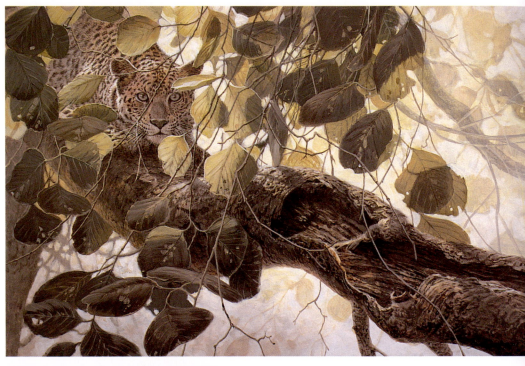

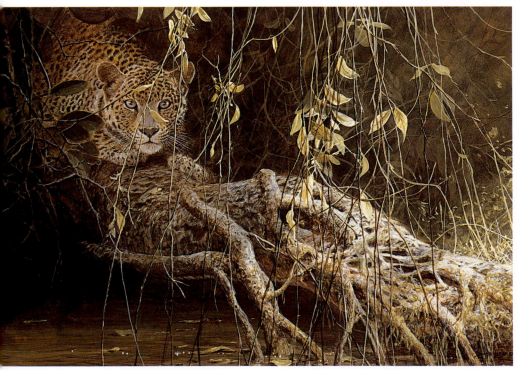

COMPLETE PAINTING

I roughed in the background with a dark mixture of equal parts Burnt Umber, Payne's Gray and Ultramarine Blue mixed with water. I then roughly painted in the water area with Payne's Gray, Raw Sienna and Burnt Sienna. Using horizontal strokes and a ¼-inch (6mm) flat brush, I painted in some foliage in the background with Yellow Ochre and Payne's Gray. Then I applied several washes of the dark mixture over the foliage. Next I painted in the tree roots and added the vines. I changed the lighting on the cat to match the new setting by applying another wash of the dark mixture and enhancing the highlights. I added more vines over the cat with a very opaque mixture of gesso, Yellow Ochre and Ultramarine Blue. Then I applied a thin wash of Burnt Sienna over the whole painting with a 2-inch (51mm) house-painting brush to tie it together.

YOUNG PREDATOR
20" × 30" (51cm × 76cm) | Acrylic on Masonite | 1992

Painting Pelicans in Oil

MATERIALS LIST

BRUSHES
Langnickel Royal sable series
5590 flats
 no. 2 ~ no. 4 ~ no. 12 ~ no.
 16 ~ no. 44

3-inch (76mm) house-painting
brush

COLOR PALETTE
Rembrandt Artist Quality oils
 Burnt Sienna ~ Burnt Umber
 ~ Cadmium Yellow ~ Cobalt
 Blue ~ Naples Yellow ~
 Payne's Gray ~ Titanium
 White ~ Ultramarine Blue ~
 Yellow Ochre ~ Viridian

Winsor & Newton Finity acrylics
 Ultramarine Blue ~ Payne's
 Gray ~ Burnt Umber

OTHER
Liquin
turpentine
white gesso

SURFACE
48" × 48" (122cm × 122cm)
 canvas

I usually don't draw an image on my canvas to start out. I just jump right in with a brush. To draw with a brush, as I call it, indicate the general forms of the composition with brushstrokes rather than outlining the scene with graphite.

1 | BLOCK IN MAJOR ELEMENTS
Prime the canvas with a mid-gray mixture of Ultramarine Blue, Payne's Gray and Burnt Umber acrylics and white gesso. Now working in oil, block in the painting's major elements loosely to establish the composition. First, paint in the birds with a mixture of Titanium White and Naples Yellow and a no. 12 flat sable brush. Keep it loose. If some of the birds aren't quite proportionate, you can adjust them later.

While the pelicans are still wet, work on the background. Paint in the trees with a mixture of Payne's Gray, Cadmium Yellow and Burnt Sienna. Use the same mixture to paint the water in the background, adding more Burnt Sienna and some Yellow Ochre at the top and blending with Cobalt Blue at the bottom. Block in the lower part of the painting with a 3-inch (76mm) house-painting brush.

2 | ADD DETAILS TO CENTER OF INTEREST
Adjust the scale of the pelicans if necessary by painting more detail in the immediate background and adding the reflections. Paint the background detail with no. 4 and no. 16 flat brushes and Payne's Gray, Burnt Sienna and Yellow Ochre. Add details to the pelicans with the same brushes and Titanium White and Naples Yellow. Don't add any detail to the water at this point.

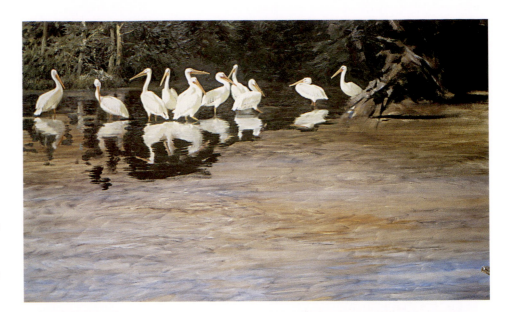

3 | ADD MORE DETAILS

Using the same brushes, add more detail to the pelicans and the background. Darken the water immediately behind and under the birds and define the pelicans' reflections with a mixture of Burnt Sienna and Payne's Gray.

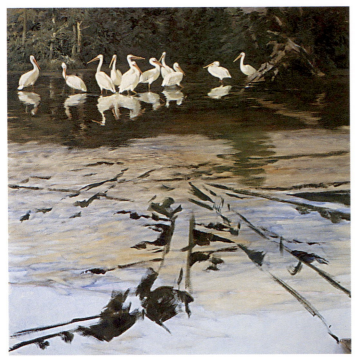

4 | ESTABLISH DESIGN

With a mixture of Cobalt Blue and Burnt Sienna and a no. 44 flat sable brush, block in the foreground logs underwater to establish the design. Paint the pelicans in more detail with a thicker mixture of Titanium White and Naples Yellow. Paint the shaded areas on the birds with Yellow Ochre and Payne's Gray and no. 2, no. 4 and no. 16 flats. Paint one bird at a time, and while the paint is still wet, finish the background behind each bird, pulling the paint into them to soften the edges. Repeat this technique until each bird is complete. Then refine the pelicans' reflections in the water the same way, and paint the water directly under the birds.

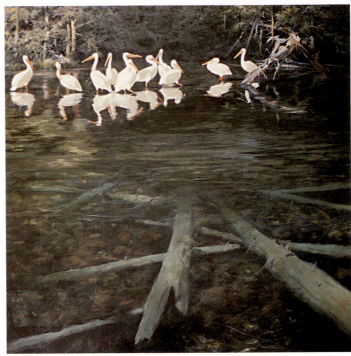

5 | PAINT FOREGROUND

Now that you've completed the upper portion of the painting, you can concentrate on the foreground. Paint the rocks and logs underwater with a no. 44 flat sable brush and a mixture of Burnt Sienna and Cobalt Blue, painting the negative shapes first. While the paint is still wet, add some highlights on the rocks with Yellow Ochre, Ultramarine Blue and Titanium White and on the logs with Viridian and Payne's Gray. Paint the rocks and logs loosely with a wavy brushstroke to give the impression of distortion through the water. Let the painting dry completely.

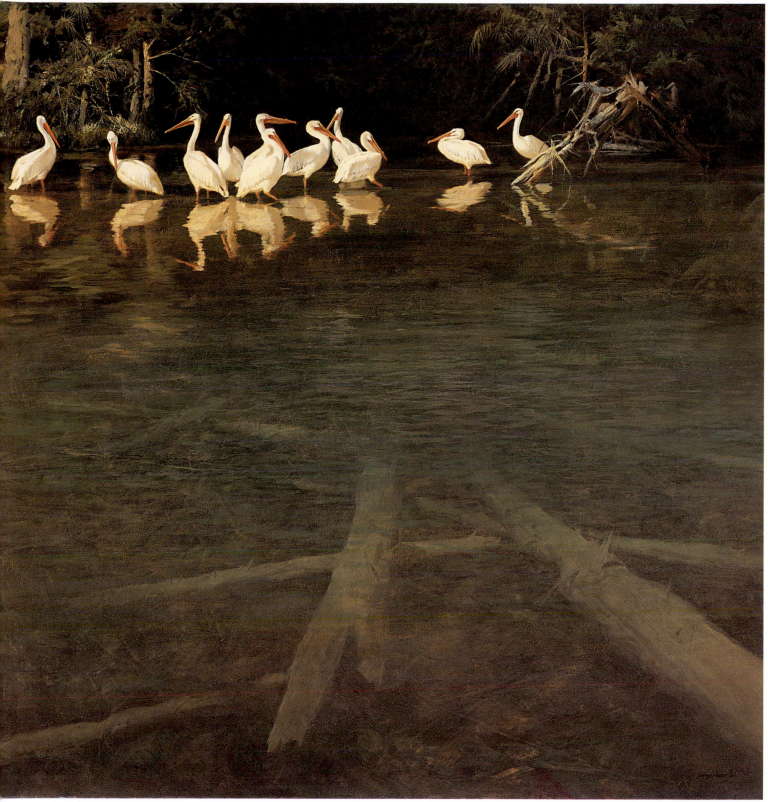

6 | APPLY GLAZES

With a 3-inch (76mm) house-painting brush, apply a glaze of Yellow Ochre, Burnt Sienna, turpentine and Liquin over the top third of the painting. When this is dry, apply the same glaze over the entire painting to create a warm glow. When the second glaze has dried, apply a glaze of Payne's Gray, turpentine and Liquin over the lower two thirds.

EVENING TRANQUILITY
48" × 48" (122cm × 122cm) | Oil on canvas | 2000

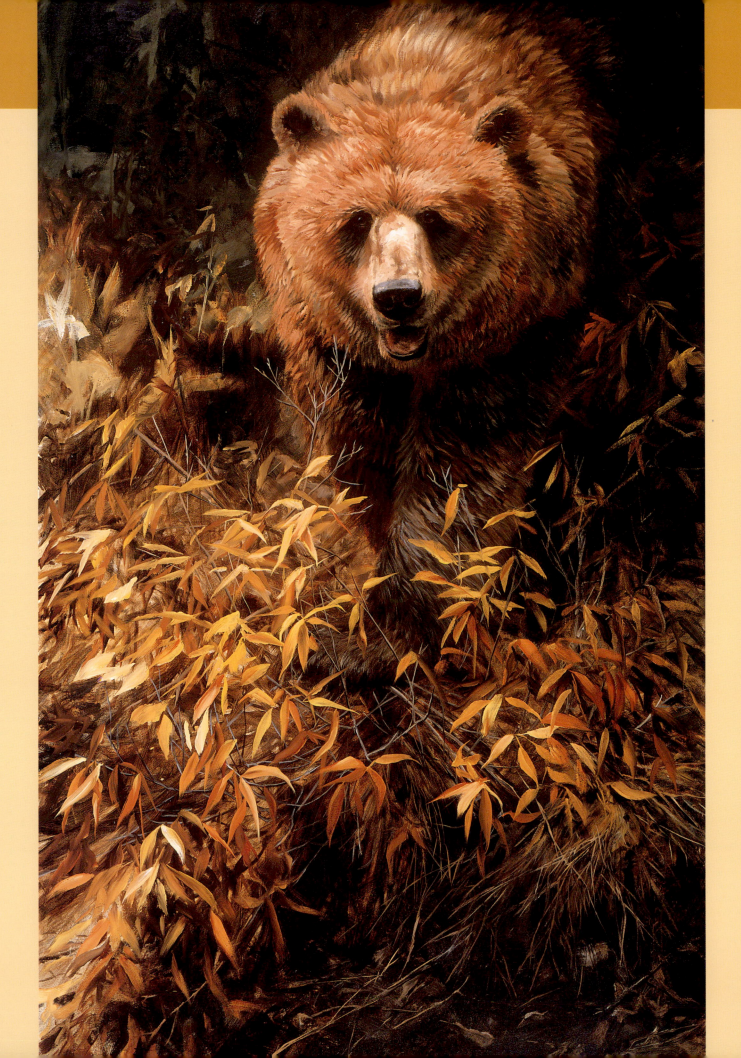

Research and Composition

The idea stage of a painting takes the most time for me. People often ask me how long it takes to do a painting. My answer: It can take years. Coming up with a concept that works is a long thought process. The more paintings I do—I stopped counting at two thousand—the harder it becomes to come up with unique ideas. But once I've developed an idea, the actual painting process may take only days or weeks. My thought process varies. Sometimes I refer to my field sketches, photos and videos, which go back many years. These references often remind me of experiences I've had in the field, which prompt new ideas. Other times, I develop a purely abstract design concept and adapt it to a wildlife subject. Abstract design allows me to work with the balance between dark and light as well as the composition without worrying about a particular subject or image.

USE IMPRESSIONISTIC APPROACH

I kept the background loose but gave the bear and the willow leaves more detail. I also minimized the detail in the immediate foreground to focus the viewer's eye on the main part of the painting.

THROUGH THE WILLOWS—GRIZZLY
60" × 36" (152cm × 91cm) | Oil on Canvas | 2000

Abstract Concepts

A good painting starts with a good composition. My paintings start as an abstract design. Only after I have a sound design do I work in my actual subject and environment. Concentrate on your balance of dark and light, the placement of your subject and how you'll get the viewer's eye to that point during the design phase.

BALANCE DARK AND LIGHT

During a preliminary study, try to proportion the dark and light areas. The small dark area at the top of this study will contain the main subject matter. Although the area is small, the darkness adds enough weight to balance the white negative space.

GO VERTICAL

A vertical design can be very dramatic, and I use the format often. One important thing to remember: Don't destroy the vertical flow by placing horizontal elements in the painting. In this study I made the dark mass the most dominant. Placing it at the top creates power, dark pushing down on light. The reverse doesn't work. Turn this book upside down and look at it again. The design just doesn't have the same impact.

CHANGE PROPORTIONS

The proportions in this study have changed from the one above. The dark area is now the more dominant. The dark mass creates power and impact by pushing down on the light area. Again the main subject will appear in the dark area, probably near the top. The type of subject matter isn't important at this stage. We're just developing a design concept.

INDICATE POWER AND STRENGTH

The main subject here is the only illuminated portion of the painting, the white circle. Still, the dark mass is the most dominant and delivers the desired drama. Anytime dark appears above light, the image emits power.

WEAK CONCEPT

By reversing the image so the subject is at the top of the picture, I've made the design weaker. The scene is bottom heavy now.

USE PROPORTIONS AND DIRECTIONAL ELEMENTS

The subject in this study appears in the same spot as the weak study (above right), but I've changed the proportions of dark and light. Now the subject is backlit with a cast shadow running diagonally from the subject to the opposite corner, leading the viewer's eye through the painting.

BAD PROPORTIONS

Dividing a scene in half with dark and light areas breaks the vertical flow.

Composing a Painting

Composition isn't a science of right and wrong. Instead, it's a process of experimentation and elimination. Play with your idea until you find a composition that works, and then stick with it.

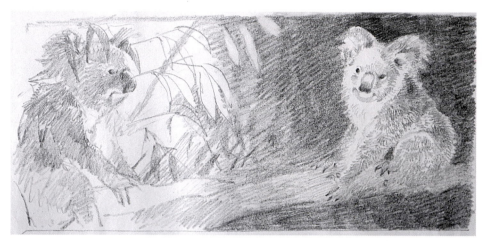

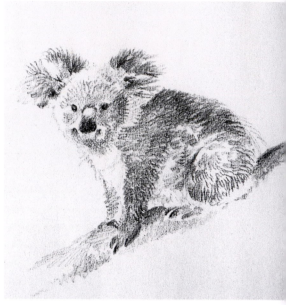

STUDY SCENE

I do several preliminary sketches before starting a painting, particularly if it's a subject I've never painted before. I did more than two dozen sketches of this koala before settling on the final concept. This study was one of the first, when I was thinking of painting a horizontal format.

ADAPT ELEMENTS

I also drew each koala in several different poses until I found one I liked.

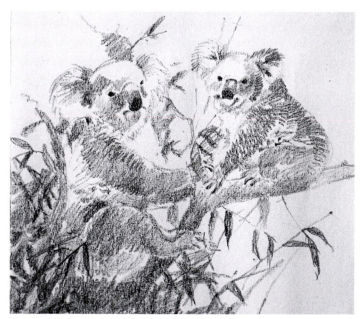

BRING SKETCHES TOGETHER

After experimenting with both koalas, I tried to bring them together, eliminating the sketches that didn't work.

FINALIZE IDEA

This is the last sketch I did before starting the painting. I was still thinking in terms of a horizontal format.

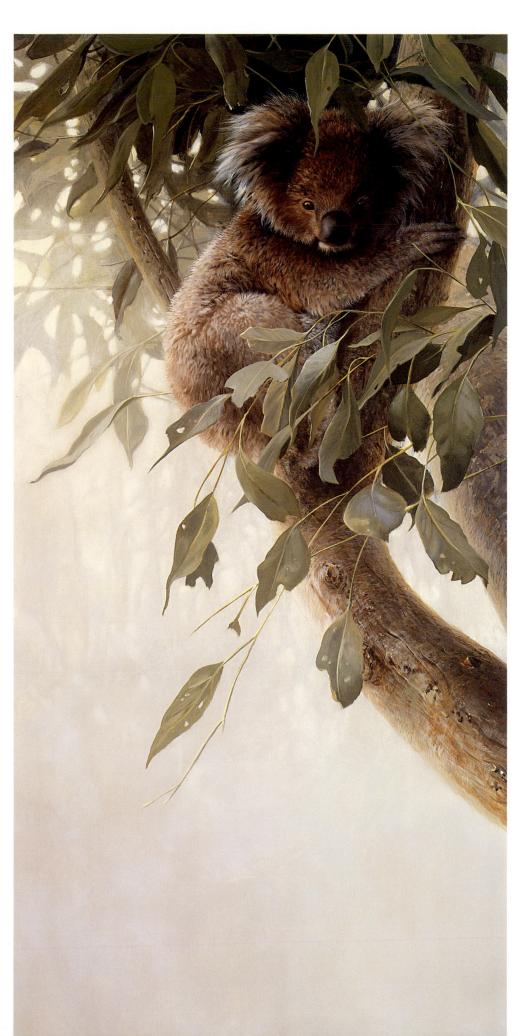

Finish Painting

My final painting ended up as one koala in a vertical format, but I stuck with my original concept of a dark mass at the top and negative space at the bottom, an almost Oriental design. The tree trunk helps bring the viewer's eye up to the koala. Although the painting differs from the sketches I did to prepare for it, each of the sketches gave me insight that contributed to the painting.

CHILD OF THE OUTBACK
36" × 18" (91cm × 46cm) | Mixed media on Masonite | 1993

Preliminary Studies

More often than not, none of the preliminary sketches I've done for a painting becomes a final painting. Instead, I use them in a process of elimination. Once I start a painting, I adapt the concept as I go, keeping the original idea still firmly embedded in my mind. Once you've established an abstract idea or design concept, don't drift from that path. If it's not working, develop another idea. If the design itself isn't working, a painting based on that idea won't work either.

ADD COLOR TO GRAPHITE

I added watercolor to a graphite study to create this study. I applied a wash of Cobalt Blue and Payne's Gray over the shaded graphite areas to get an idea of how the bear would appear if standing in moonlight.

TRY DIFFERENT DIRECTION

At this point I thought it would be a better idea to set the bear under water, an idea which would remain close to my original design concept. So I went to a zoo and sketched a polar bear from an underwater viewing tank. After observing and sketching the bear, I decided to do the more finished study (at left) in oil, based on the underwater concept. Notice that the lighting concept is similar to the graphite and watercolor study above. Now the bear is just underwater!

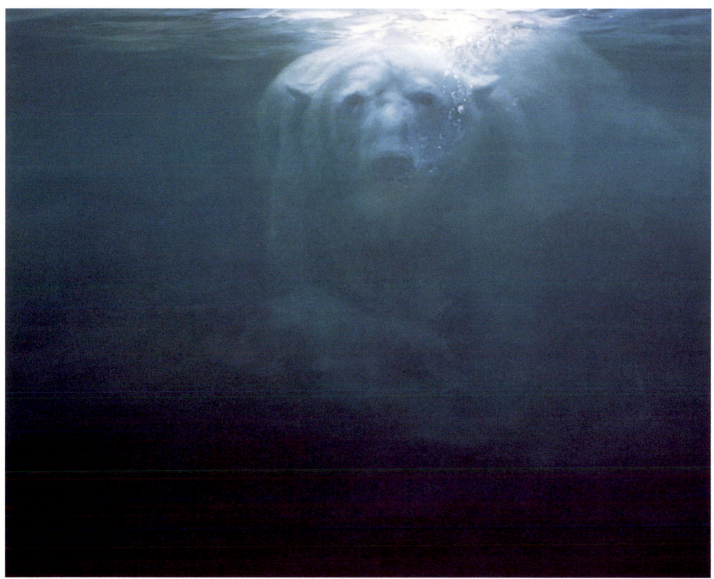

Finish Painting

I developed this final idea using my field sketches and original studies in graphite, watercolor, acrylic and oil. I wanted the polar bear to disappear into the water so only the head and the disturbed surface of the water would be illuminated. I primed the canvas with a gray gesso mix. I painted the water with several coats of Viridian, Alizarin Crimson, Ultramarine Blue and Titanium White. I painted the shadow area of the bear with a series of glazes using the same mixture with turpentine added. When this was dry, I laid an overall glaze of the same mixture with turpentine and Liquin over the whole painting. When this dried, I emphasized the highlights on the surface water with Naples Yellow, Viridian and Titanium White. I highlighted the polar bear with Yellow Ochre, Viridian and Titanium White.

ICE FISHING
48" × 60" (122cm × 152cm) | Oil on Canvas | 1994

Secondary Points of Interest

To make a painting more memorable, I like to introduce a secondary point of interest. Any element will work as long as it's not immediately noticeable by the viewer. Sometimes I make the subject a secondary point of interest by trying to direct the viewer's eye to another part of the picture. This seems to give a painting longevity. If the viewer sees everything immediately, the painting will become boring quickly. As I observe my subjects in the field, I've noticed that, more often than not, an animal or bird is obscured by its habitat. And sometimes I discover it only after some time. Why not let the viewer of your painting have the same experience?

ADD SOME SPLASH

The focal point here is the rushing tiger. I kept the background simple to maximize the tiger's movement without obstructing the flow. The secondary point of interest is the splash in the water from some unknown prey. Who knows? It could have been me!

RANTHAMBHORE RUSH
24" × 36" (61cm × 91cm) | Acrylic on Masonite | 1992

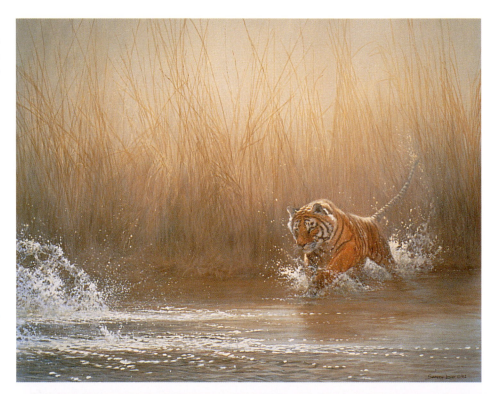

DELAY DISCOVERY

The viewer will notice the focal point, the illuminated foliage and dead grass to the right, immediately. But I used other elements to direct the viewer's eye to discover the black panther, the secondary point of interest and subject of the painting, in the shadows. I use this formula often. It suits many of my design concepts as well as my real experiences during field observations.

BLACK MAGIC—PANTHER
24" × 36" (61cm × 91cm) | Acrylic on Masonite | 1992

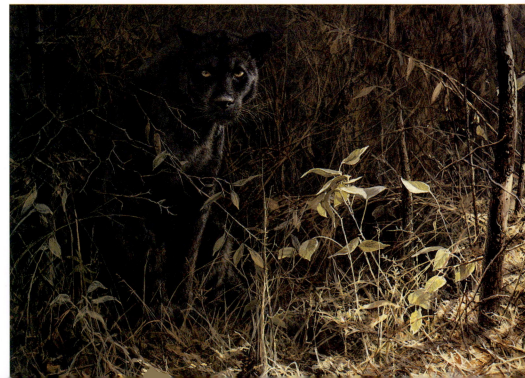

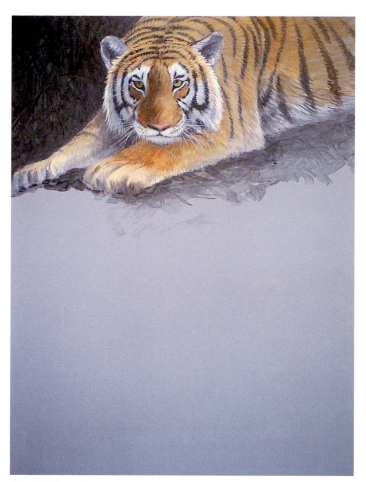

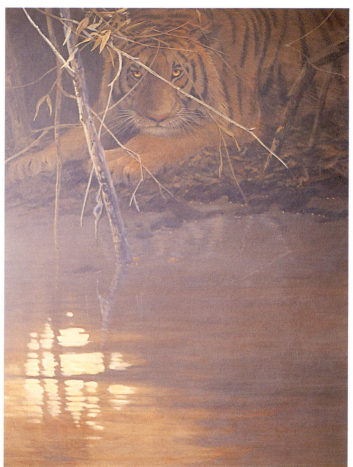

START WITH SUBJECT
I blocked in the tiger, the main subject, in acrylic, and added detail.

FINISH PAINTING
I applied alternating washes of a dark mixture of Payne's Gray, Burnt Umber and Ultramarine Blue and then Burnt Sienna to push the background, including the tiger, back. The key to this painting is the light catching the water in the foreground. It becomes the primary focal point of the composition so the viewer can "discover" the tiger later.

SUNDOWN GLARE
40" × 30" (102cm × 76cm) | Acrylic on canvas | 2001

Movement

Whenever you're painting a scene that has movement, whether it's a bird flying or an animal running, don't place an element—a tree, mountain, rock or even a blade of grass—in the path of the animal. If you place a tree in front of a wolf in motion, even on a different plane, you'll stop the wolf's movement across the surface.

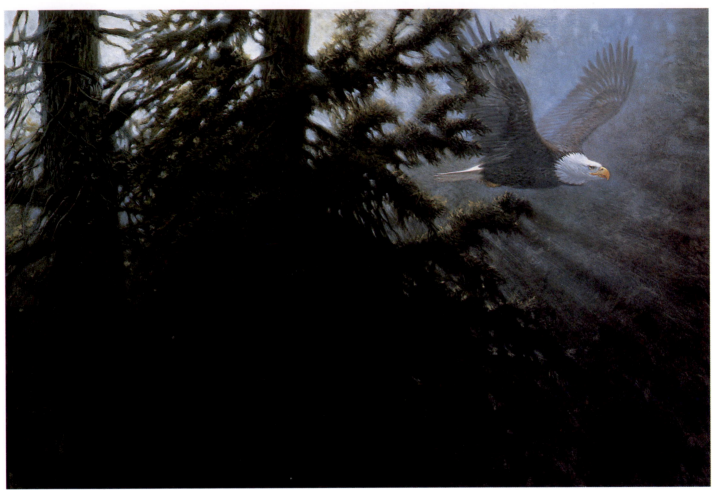

CREATE FLOW OF MOVEMENT
Just as still objects can stall moving objects, they also can enhance the movement if used correctly. The tree behind this eagle adds power to the flight of the bird.

MORNING GLORY—BALD EAGLE
24" × 36" (61cm × 91cm) | Mixed media on Masonite | 1993

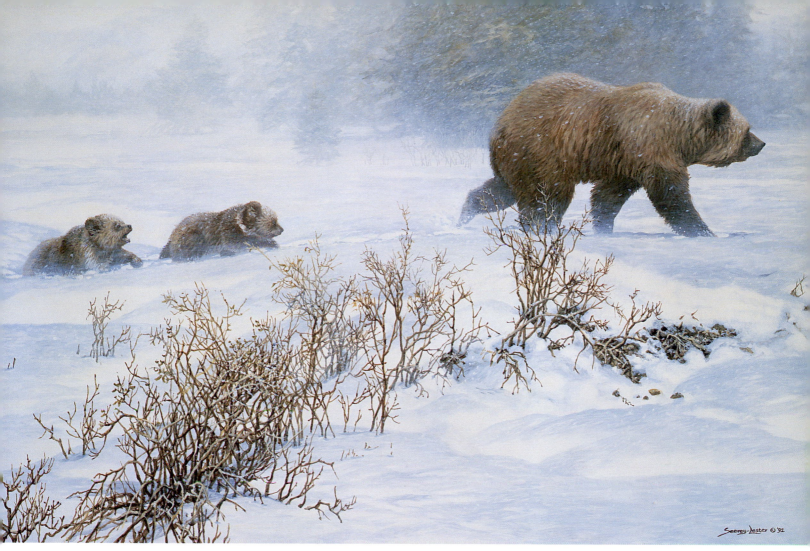

DON'T BLOCK MOVEMENT

This composition allows a flow of movement from left to right. The willow bushes in the foreground sit below and behind the moving bears. I placed a mist in front of the background trees to push them back so they won't interfere with the bears' path.

KEEPING PACE—GRIZZLY AND CUBS
24" × 36" (61cm × 91cm) | Acrylic on Masonite | 1992

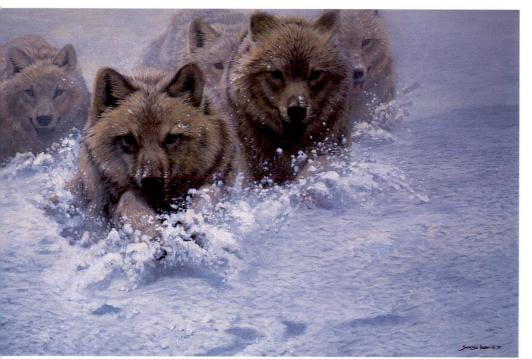

ENHANCE MOVEMENT

Here the wolves are running toward the viewer. I placed no obstacles that would restrict their movement or stop the action in their path. One wolf leads the pack, which adds to the movement.

ARCTIC WHITEOUT—ARCTIC WOLVES
24" × 36" (61cm × 91cm) | Acrylic on Masonite | 1997

Some Work, Some Don't

Artists often dislike particular paintings once they finish them. When people ask which of my paintings is my favorite, my usual answer is, "my next." If we, as artists, achieved exactly what we wanted each time, we'd never progress. Don't be despondent. Always think positively: "My next one will be great."

FINISH TWO, KEEP ONE

When I finished the painting at top, I realized it wasn't working as I'd planned. The lighting was OK, but I felt the setting needed something more and the pups were too hidden. I decided it would be more interesting to silhouette the wolf pups than to place them in the snow, so I changed the setting, painting dead leaves on the ground for the painting above. The viewer can see the dark wolf pups more easily in my second effort.

YELLOWSTONE'S FUTURE
12" × 36" (30cm × 91cm) | Acrylic on Masonite | 1997

KEEP IT SIMPLE

Every painting has a better chance of working if you keep it simple. Correctly placing the duckling that jumped from the nest was vital for this painting to work. I placed the second duckling, about to leave the nest, high up in the piece and subdued it and the background's values so they wouldn't interfere with the downward movement of the falling duckling.

LEAVING THE NEST—WOOD DUCKS
60" × 12" (152cm × 30cm) | Acrylic on Masonite | 1995

Stay on Track

I've said before that I like to create during the painting process, but I've found that if I don't stick to the general design and lighting concept, I sometimes get in trouble. You can alter elements in a painting, but stay on track once you've developed the basic idea.

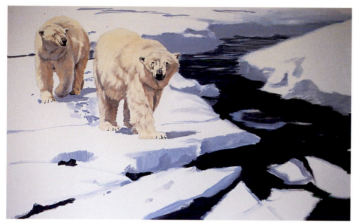

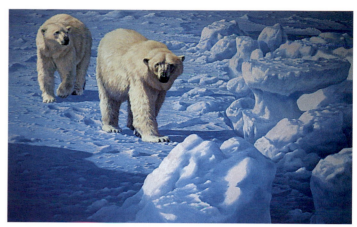

STICK TO DESIGN
My original idea had polar bears walking along broken ice with the simple contrast of dark against light powering the painting. As I worked on the painting, though, I changed the lighting and created an ice floe, which became too complex and wasn't necessary.

ALONG THE ICE FLOE—POLAR BEARS
30" × 48" (76cm × 122cm) | Oil on canvas | 1986

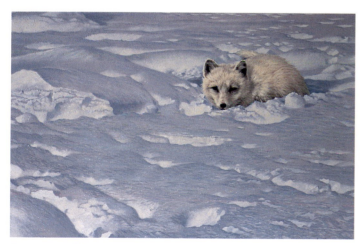

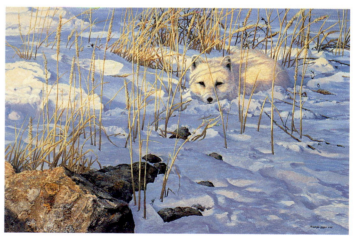

SIMPLICITY WORKS
Again my idea was simple and should have worked well. I liked my original use of lighting, but at the time, I felt the painting needed something more dramatic. In the finished painting at right, I changed the light source and added rocks and grasses. In my opinion, the end result wasn't as successful as the original idea. Often, simplicity works.

LYING IN WAIT—ARCTIC FOX
24" × 36" (61cm × 91cm) | Oil on canvas | 1987

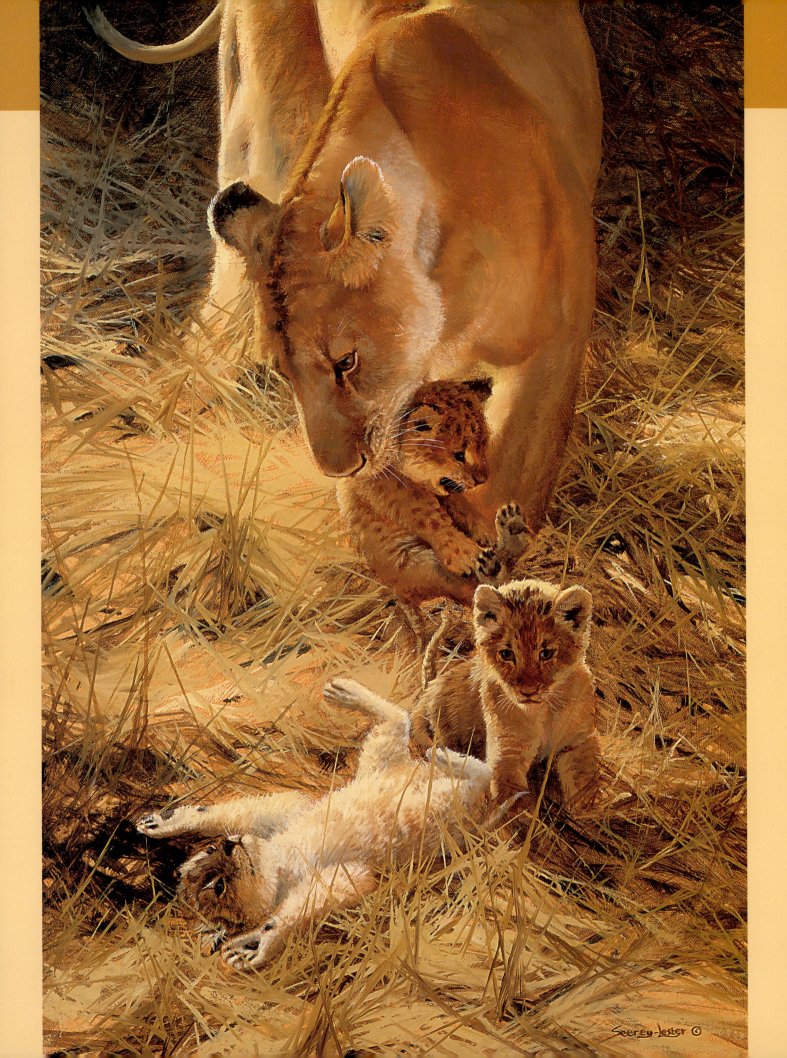

Seerey-Lester ©

Fieldwork

Sketch. Sketch. Sketch. Fieldwork is the most important part of wildlife painting. Without firsthand knowledge of the subject you want to paint, whether it's an animal, bird or habitat, your painting will lack authenticity. Take advantage of being in the field. Don't just take pictures. Sketches and field paintings have so much value. When you do a field sketch, you learn so much more about the wildlife and habitat than if you just took a photo. In college, my professors sometimes asked the students not only to read chapters, but also to copy them by hand. This process embedded the text in my memory far more than reading alone would have. The same learning capacity applies to sketching a scene rather than simply capturing it on film. I did my first field sketch when I was eight years old, and I've sketched my subjects from life ever since. Photography is a necessary tool for fieldwork, but use it only as a supplement to your field paintings and sketches. Once you've sketched an animal from life, you've attained the understanding you'll need to accurately read your photographs.

Zoos and nature and animal preserves are great resources in addition to the real wild. I use them often. Remember to compensate for the fact that most animals in a zoo or preserve are probably overweight. Bird feathers, particularly tail feathers, might be damaged or frayed from living in captivity. I've seen paintings in which the artist painted birds with clipped wings without realizing it. Captive wildlife is a great reference, but be careful how you portray it. When sketching and painting animals or birds from life, get as much information as possible to help with the finished piece. Each chance you get to observe a certain kind of wildlife may be your only one.

USE FIELD SKETCHES
I based this painting on several field sketches done in Africa.

MARSH LIONS—A NEW GENERATION
24" × 16" (61cm × 41cm) | Oil on canvas | 1999

Choose the Medium

You can do field studies in any medium and on any surface. It all depends on what you want to achieve. I avoid pastel when working in the field because I've found the finished works too fragile to transport. I use graphite HB and 2B pencils, watercolors, watercolor pencils, acrylics and oils in the field. I usually use the same brushes I would use in my studio. My most versatile surface is Strathmore 3-ply kid finish paper. It takes graphite, watercolor, watercolor pencil and acrylic. Most importantly it holds oil paint without oil rings. I carry a separator box to carry oil and acrylic paintings back to the studio. You can make one yourself or buy one from your local art supply store.

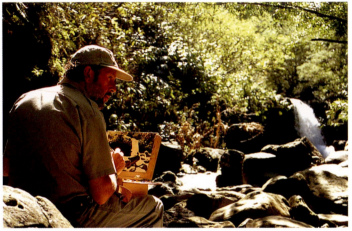

TAKE IT ALL IN
I used oils and a Pochade box to paint this waterfall in Maui, Hawaii. The rich colors and thick texture of oil paint captured the scene.

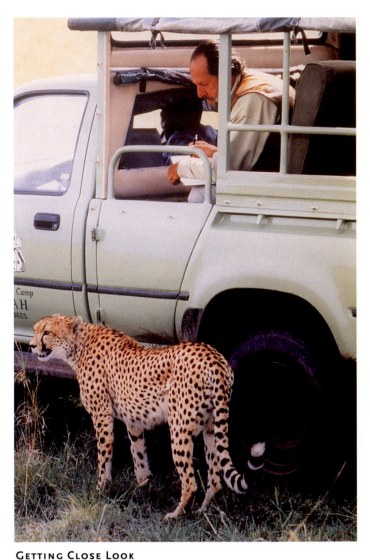

GETTING CLOSE LOOK
In this case, the field is Maasai Mara, Kenya, East Africa.

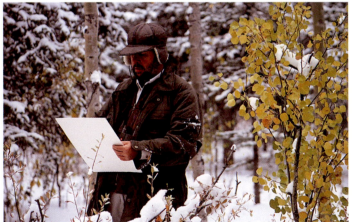

FIELD SKETCHING IN DENALI NATIONAL PARK, ALASKA
Acrylics are easier to use in some environments, such as cold, Alaskan weather.

Fighting the Elements

You'll be fighting the elements as you work in the field, so make sure you select the right medium for the conditions. I have worked everywhere from the arctic to Antarctica and many places in between. When working with watercolor or acrylic in cold conditions, add alcohol to your water to prevent it from freezing. It's no fun chipping ice off your water jar! Acrylics also dry very quickly and oil paint crystallizes and becomes less pliable in cold, dry conditions, so you have to work quickly. In humid conditions, on the other hand, it takes a long time for water-based paints to dry, so you have to be more patient than usual; laying in washes can be difficult.

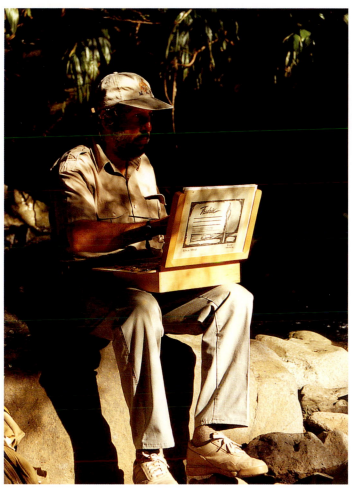

HIDE OUT
Though the sun would have been a welcome sight when I was painting in Alaska and Antarctica, sometimes I have to hide from it, too, as I did in Ranthambhore, India.

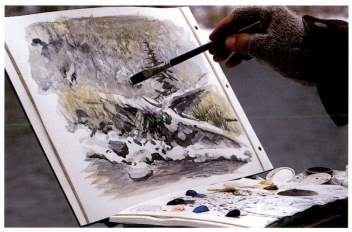

GET TRUE EXPERIENCE
Without the comforts of my studio, I have to use other means, such as fingerless gloves, to create suitable working conditions in places like Alaska.

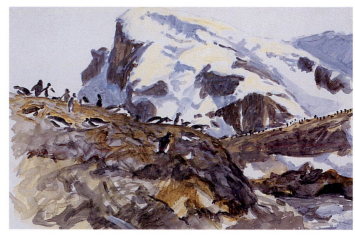

WATER TURNS TO ICE
I painted this watercolor on a trip to Antarctica. The weather was very cold, making painting difficult, so I added alcohol to my water jar to keep it from freezing. I carry rubbing alcohol when I go to an extremely cold climate just for this purpose. My Cotman watercolor box has a thumb holder underneath it so I can hold it like a palette in my left hand along with a 6" × 8" (15cm × 20cm) panel. I wear a fingerless glove on my right hand so I can control my brush.

Graphite and Charcoal Field Studies

Before putting color down, I use graphite or charcoal to do a field sketch. These sketches contribute a great deal to the final painting. Try to record as much information as possible in your sketches. Sometimes concentrate on just one detail—perhaps a bird's bill or foot, a wolf's fur or another particular characteristic you haven't studied in depth. Every sketch you do could be your only opportunity to get the information you need. Black-and-white sketches can be works of art themselves, but their main purpose in fieldwork is research and gathering information.

CAUGHT IN THE MOMENT
I particularly liked the moose's pose and wanted to capture it before the moment passed. I managed to gather enough information about this Alaskan moose in this sketch for a painting without having to do a color study.

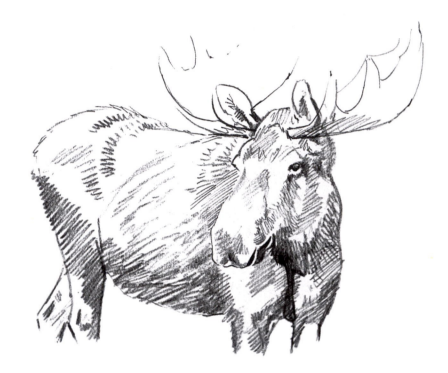

STUDY DETAILS
You don't have to plan an entire painting every time you sketch in the field. Take opportunities to build up your stock of reference materials.

Using a 2B graphite pencil, I sketched the feet of a woodpecker (top left), which it uses to climb trees. I studied how the woodpecker positions its feet. I sketched an owl's feet (top right) as it sat on a tree branch with two talons forward and two on the other side of the branch. The talons of a captive eagle appear at bottom left. Even though the eagle was captive, this may be the closest I'll ever get to an eagle's foot, so I gathered as much information as I could. Great blue herons approach our back deck all the time, so I've sketched them close-up many times. At bottom right, though, I concentrated on the feet only.

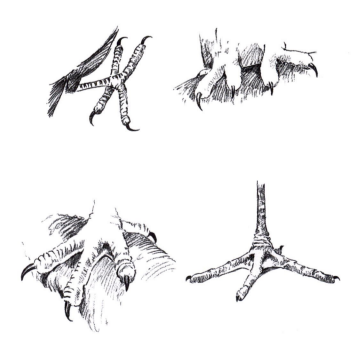

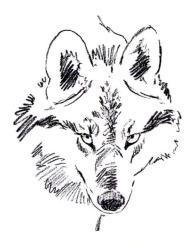
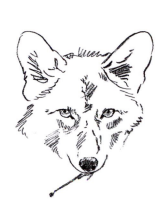
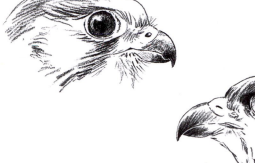

DRAW COMPARISON SKETCHES

When sketching in the field, record the true characteristics of the animal you're studying. Comparison sketches are useful as learning exercises and references for later studio work. By accurately recording each animal, I can study the differences and more accurately paint either one later. Notice the differences in the angles of the eyes and ears, the length of the snouts and the hair between the wolf (top left) and the coyote next to it. The hawk (top right) lacks the tooth in the bill that the falcon next to it has. The hawk's eye is also more sunken in. The differences between animals can teach a lot about how to draw or paint each animal individually.

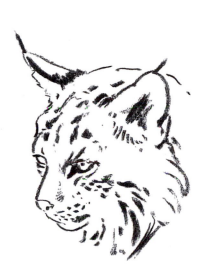
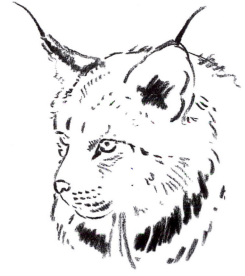

COMPARE CATS

These graphite sketches of a captive bobcat (above left) and lynx (above right) show the differences between the two, which will be vital information for a later painting. The lynx has longer ear tufts and is a generally larger animal than the bobcat. Its larger paws help it travel through its snowy habitat easily.

COMPARE EAGLES

Juvenile bald eagles can be easily mistaken for golden eagles (far left) until they develop the distinctive white feathers of the adult bald eagle (near left). The bald eagle has a larger head and larger and heavier beak than the golden eagle.

Watercolor Field Studies

Watercolor dries quickly and you can layer watercolors while they're still wet, making it an ideal medium to use in the field. First do a light pencil drawing; heavy lines show through transparent watercolor. Lay in a light wash for the main subject and another for the background. Then build up the detail areas, leaving the white of the paper for any areas that will be light. Add as much detail as you want for the foreground. Although watercolor is a very unforgiving medium, you can repair mistakes by lifting some paint from the area; add water, then dab it dry with a paper towel. You also can create highlights this way.

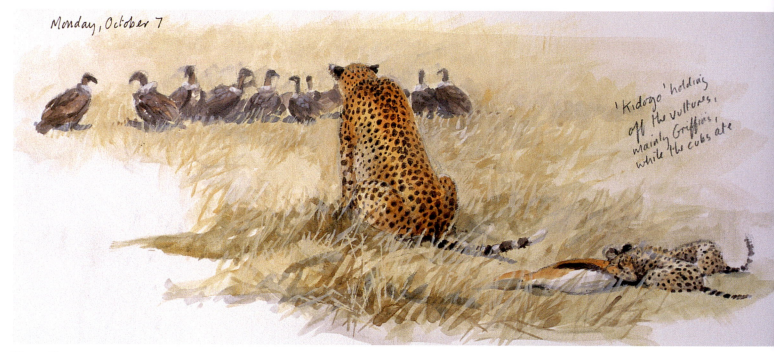

Monday, October 7

'Kidogo' holding off the vultures, mainly Griffons, while the cubs ate

WORK QUICKLY

I sat in our truck as I painted this study in Kenya. I drew a quick, light pencil sketch before applying the watercolor. I had to work very fast because the cheetah didn't sit in this position very long. She was protecting her cubs and their dinner, a gazelle she had killed, from the vultures.

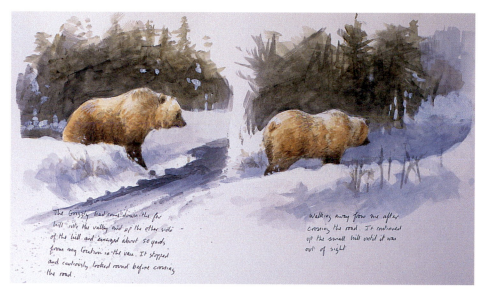

The Grizzly had come down the far hill into the valley and up the other side of the hill and emerged about 50 yards from my location in the van. It stopped and cautiously looked round before crossing the road.

Walking away from me after crossing the road. It continued up the small hill until it was out of sight.

PLOD ALONG

I painted these two watercolor studies of a single grizzly in Alaska. I sketched the bear as it crossed the road right in front of me. You get a real sense of the bear's strength and slow but steady movement with this progression of sketches. As I painted, I stood next to our camper at a safe distance from the bear, if there is such a thing. I again had to work fast because the light was fading. I applied washes of Raw Sienna and then Burnt Sienna on the bear. I used Burnt Umber for its shadows, then moved on to details.

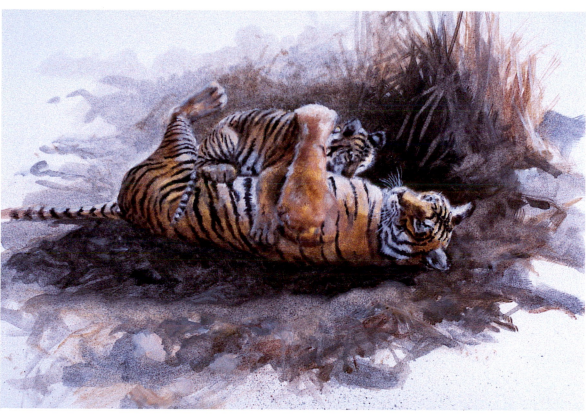

SKETCH QUICKLY

I did this field sketch of a mother and her cub in Ranthambhore, India, from the truck. I quickly sketched the tigers in pencil, then worked in color as the tigers moved away. After they left, I worked on the surroundings.

Watercolor Pencil Field Studies

Watercolor pencil is a great medium to use when working in the field, particularly for quick sketches. Use the colors you need to sketch the scene as you would use graphite. I usually use Derwent Burnt Umber, Gunmetal, Ivory Black, Ultramarine, Burnt Sienna, Terracotta, Burnt Yellow Ochre, Raw Sienna, Sap Green, Deep Cadmium and Spectrum Orange. I try to use a minimum number of colors for each sketch. Sketches should be simple, and a limited palette helps me sketch quickly. When you're done drawing, blend the colors with a brush loaded with clear water. You can't lift color when using watercolor pencils as you can with regular watercolor. You can go back and emphasize certain colors by drawing over the areas again, then reapplying water.

JUST PASSING THROUGH

I loosely drew these elephants with an Ivory Black watercolor pencil. I added the shaded areas on the elephants with Burnt Umber and Gunmetal, leaving the highlights white. Once the elephants moved on, I drew the environment around them.

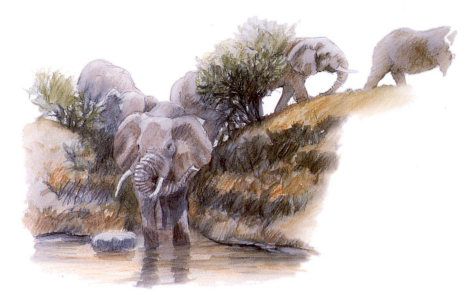

HANG OUT

This leopard was a complex image to produce. I first drew the cat and its kill with a Burnt Yellow Ochre outline and no shading. I drew in the cat's markings with Ivory Black and added water just to the markings. Then I added shading with Deep Cadmium and Raw Sienna.

Sketching Lions in Watercolor Pencil

MATERIALS LIST

COLOR PALETTE
Burnt Sienna ~ Burnt Umber ~ Deep Cadmium ~ Gunmetal ~ Ivory Black ~ Sap Green

OTHER
water

SURFACE
sketchbook paper

This sketch of marsh lions from the Maasai Mara, Kenya provides an opportunity for you to experiment with watercolor pencils. You can capture the animal quickly, without having to lay down water, and the limited palette saves even more time you can use to study the animal. Once you've gathered all of the information you can or the animals move, then you can apply water.

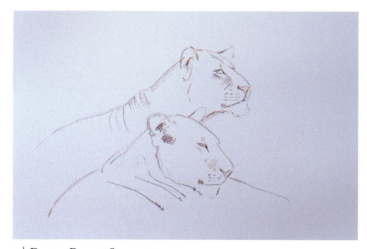

1 | DRAW BASIC SKETCH
Start this sketch of marsh lions with Burnt Sienna. Once you're satisfied with the base drawing, emphasize the lines with Burnt Umber.

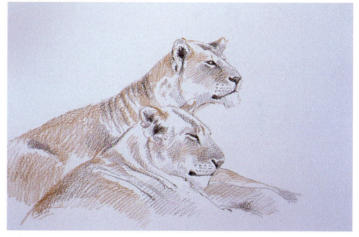

2 | ADD SHADING
Add shading with more Burnt Sienna and Burnt Umber. Add Ivory Black to the dark areas around the nose pad, mouth, ears and eyes. Use Gunmetal on the shadow areas of the white fur around the cheek, ears and muzzle.

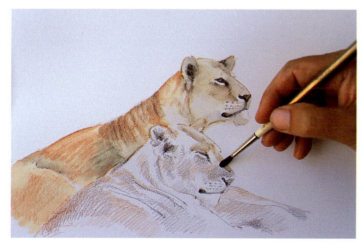

3 | APPLY WATER
Lay in the wash quickly while paying attention to the lion's muscle structure. Apply water to the darker areas first, then blend into the lighter areas.

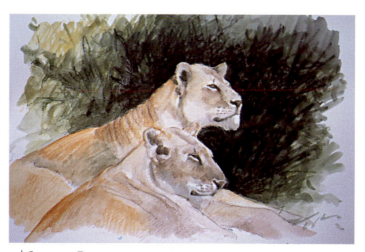

4 | SKETCH BACKGROUND
Take advantage of the time you have an animal in sight. Once you've gathered all the information you can, work on the background. Start with Ivory Black, then add Sap Green to the spaces not touched by black. Add Deep Cadmium to the rest of the open areas, especially on the left. Add water and blend as you did in step 3.

Acrylic Field Studies

When using acrylics in the field, I use Strathmore paper, canvas panels or my mid-gray primed Masonite. Paper obviously is easier to carry, particularly on an extended field trip. I cut the paper to 11" × 17" (28cm × 43cm) and carry it between two pieces of Masonite to keep it flat. Then I attach the paper to a piece of Masonite with rubber bands for a hard surface to work on. When I return to the studio, I put the completed studies in a binder. For shorter excursions, I just carry several Masonite panels. Take a jar of mid-gray gesso primer into the field with you so you can redo an area that isn't working easily and quickly.

ESTABLISH SCALE

I added a bear to this study of Chatterbox Falls in the Gulf Islands, British Columbia, Canada, to establish the scale of the scene. I had sketched the black bear the day before. After I painted the waterfall and the background and let it dry, I pushed it back by applying a series of washes of gesso and water. Then I painted in the trees, foreground and bear. The bear helped establish the scale of the trees.

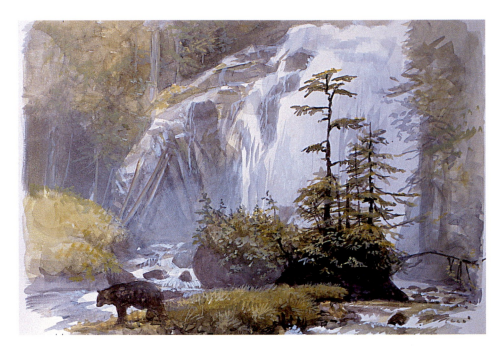

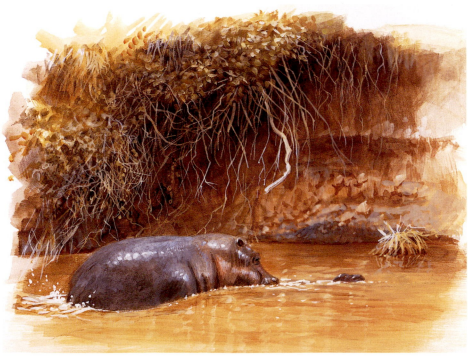

WATCH FROM CAMP

I did this study in East Africa from behind our tent on the Mara River. I used my ⅜-inch (10mm) flat brush, which I use for 50 to 75 percent of my field painting.

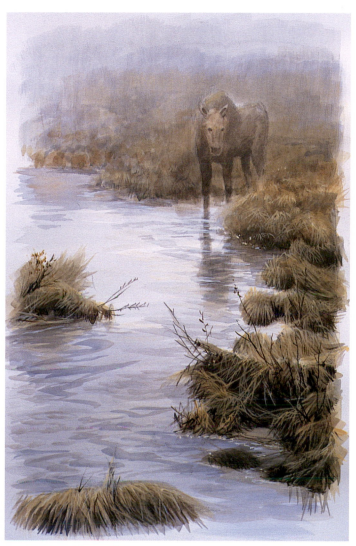

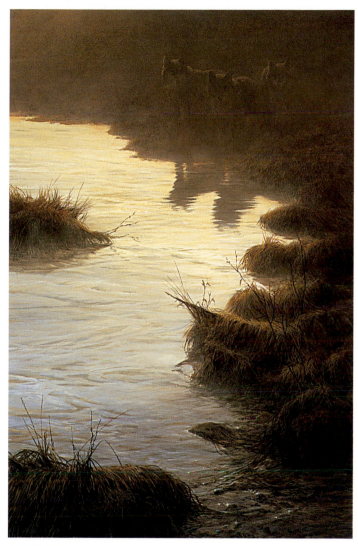

START WITH FIELD SKETCH

I painted this field painting of a cow moose in Alaska but later adapted it for a different animal. The setting—the light on the water and the grasses—is what impressed me about the scene. I added the moose for scale. I used acrylic paint almost like watercolor, very softly and subtly and working from light to dark. Acrylic painting is like painting in a mist. As you paint darker washes, the mist lifts to reveal a clear image.

ADAPT SCENE

I adapted the setting of the painting at left for this painting of wolves. I was on a wolf watch in Alaska and had seen wolf tracks the previous day. The wolves seemed to be using a regular route, so I parked my camper close to the tracks and stayed awake all night hoping to see them. My eyes started playing tricks on me as the night progressed. There was a body of water on the tundra near the camper, similar to the one in the moose sketch. I could have sworn that I saw reflections of wolves in the water, even though I couldn't see the wolves. I did a quick sketch anyway. When I returned to the studio, I adapted the moose field sketch, darkening the setting and adding the phantom wolves.

PHANTOMS OF THE TUNDRA
36" × 24" (91cm × 61cm) | Oil on Masonite | 1993

Painting a Grizzly in Acrylic

If you're sketching both an animal and its habitat, make sure you get the animal down first. Once you've established your subject and recorded the information you want, you can concentrate on the rest of the scene—the habitat and the environment—for as long as you'd like.

1 | BLOCK IN BEAR
Prime the Masonite with a mid-gray mixture of Ultramarine Blue, Payne's Gray, Burnt Umber and white gesso. Block in the grizzly with a mixture of Payne's Gray and Raw Sienna and a ⅜-inch (10mm) flat brush. Also indicate the flow of water. Keep the paint very thin and light in value, almost like watercolor, so you can adjust it easily.

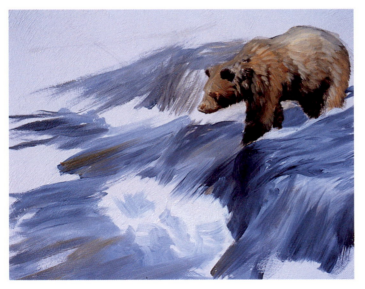

2 | ADD DETAIL
Still using the ⅜-inch (10mm) flat brush, lay in more color on the bear with Burnt Umber, Burnt Sienna, Raw Sienna and Yellow Ochre. Apply Payne's Gray on the water, then add some Raw Sienna to indicate the rocks. For now, leave the gray primer where the white water will be, but add some Ultramarine Blue to the shadow areas of the splashing foam.

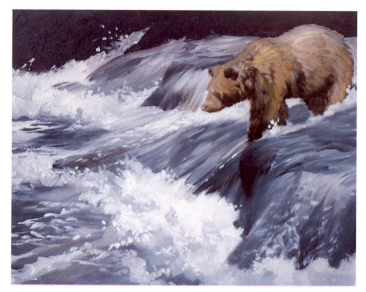

3 | APPLY OPAQUE COLORS

If you were painting in the field, the bear probably would have moved on by now. That's why it's important to get those initial washes down early. Now you can concentrate on the water and background. Add gesso to your colors with the edge of a ¾-inch (19mm) flat brush to make them more opaque. Then add more Payne's Gray to the surface of the water and Raw Sienna to the darker areas. Highlight the breaking rapids with almost pure gesso and the corner of a ⅜-inch (10mm) flat.

4 | DEFINE SPLASHES

The water won't walk away like the grizzly did, so spend as much time as you need studying and painting it. Paint the splashes with the corner of a ⅜-inch (10mm) flat brush. Then, using a stiff toothbrush dipped in a mixture of gesso and water, create haphazard splatter effects for the breaking white water. Paint in the fish with a ⅜-inch (10mm) flat brush and a mixture of Payne's Gray and gesso.

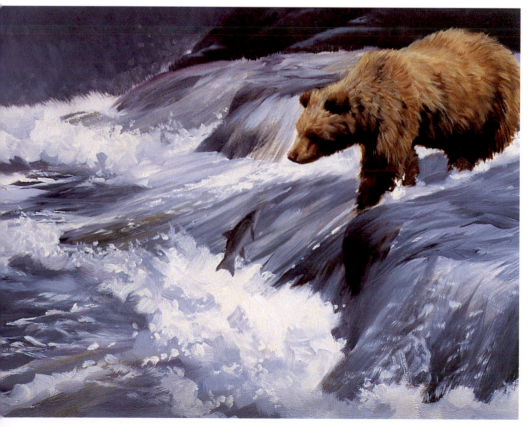

5 | PULL IT TOGETHER

Apply more detail to the bear if necessary. Apply a light Raw Sienna wash over the whole painting with a 1¼-inch (31mm) flat brush.

Oil Field Studies

I enjoy working with oil in the field, although it takes far more preparation than acrylics or watercolors. If you're flying to a remote location, research the area to see if you can buy turpentine or mineral spirits there. It's illegal to fly with these. I've traveled all over the world with oils without any trouble; just make sure you plan ahead.

When you paint in the field with oil, you have to paint positively. Sometimes I put a thin wash of Burnt Sienna over the whole canvas and then paint the lights and darks over that value rather than using the white of my canvas. First check out the light source. What is in shadow and what is illuminated? Establish the lighting pattern by painting a thin oil wash in the shadow areas only. I normally use a mixture of Payne's Gray and Raw Sienna. Your light source will change as the sun moves. Don't chase the sun; the painting will turn out flat. Once you've established the light, don't change it. Then paint more opaquely, moving as quickly as you can with positive brushstrokes.

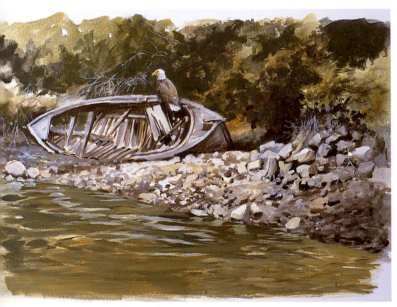

EXPERIMENT WITH MATERIALS
I painted this oil painting at Fulford Harbor, Salt Spring Island, British Columbia, Canada. The bald eagle landed on the old boat and stayed there long enough for me to paint it. Oil paint dries more quickly on my Strathmore 3-ply kid finish paper than on canvas or Masonite. The paper absorbs the paint without causing oil rings. The oil dries overnight, making this surface convenient for transporting. Unfortunately, oil paint isn't as pliable on paper as it would be on canvas or Masonite. Compensate by working faster.

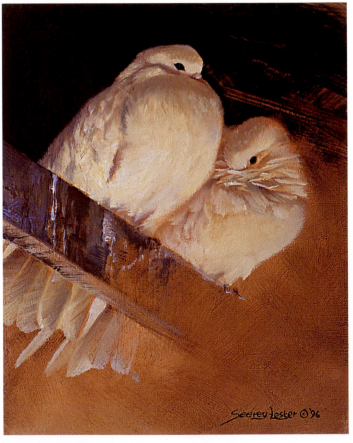

EXPERIMENT WITH LIGHT
I painted this field painting in a barn in England using a slightly different technique. I glazed the canvas panel with Burnt Sienna and a no. 30 flat brush. While the glaze was still wet, I worked in the shape of the birds with the turpentine on the tip of my brush, lifting the base color. The paint was dry enough in a few seconds to add more opaque colors. I painted the light areas on the doves, and then, while that was still wet, I painted the shadow areas on the top sides of the birds (the light source was coming from below). This study has very little detail, but broad brushstrokes give the illusion of detail. After the birds flew away, I painted the details on the beam.

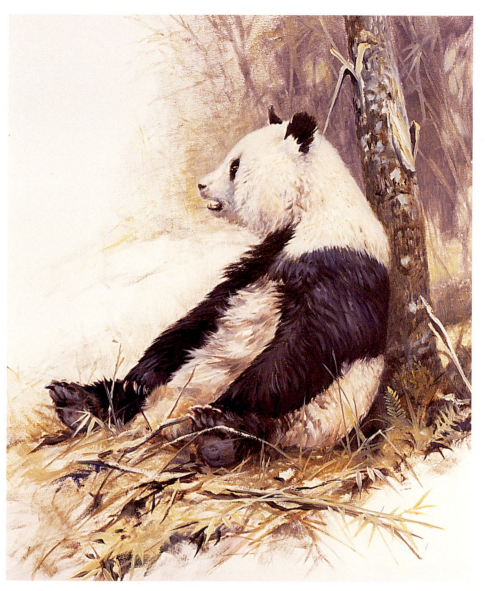

DO WHAT YOU HAVE TO DO

In the Sechuan Mountains of Western China, this giant panda sat by a tree long enough for me to paint it. I set up my French half easel right before it started to rain, so, once again, I had to work fast. I attached an umbrella to my easel to keep the rain off the painting and palette. They stayed dry, but I got very wet. I finished the panda and painted the tree and background. It was almost dark and I was soaked when I finally packed up my gear and trudged back to my lodging, but I painted a panda in the wild!

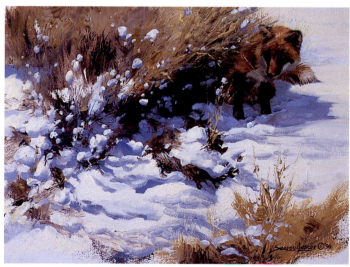

OPPORTUNITY PRESENTS ITSELF

I had almost finished my painting of the snow-covered sage in Wyoming when a red fox peeked around the corner. I blocked it in quickly before it moved. This kind of remarkable surprise has happened to me several times. It's one of the joys of painting in the field.

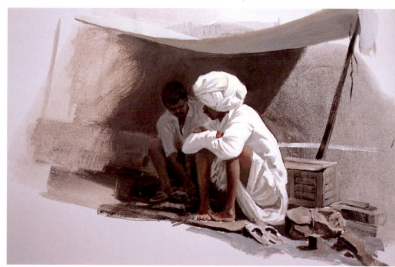

PAINT PEOPLE

Whenever I take a field trip to another country, I enjoy painting people, as in this field sketch of a street vendor in New Delhi, India. I applied a light wash of Raw Sienna, Payne's Gray and turpentine to the shadow areas with a no. 12 flat brush. The oil wash dried quickly on the Strathmore paper, so I could immediately work on the main figures with opaque paint.

Painting a Grizzly in Oil

After you've painted your subject and the habitat or background, stand back and take a look at your overall study. Even though it's a study, take this opportunity to fix any composition problems. This practice will help you create better paintings.

1 | START WITH SUBJECT
I always start with the main subject, in this case a grizzly. Without drawing, paint in the grizzly with a thin mixture of Burnt Sienna, Burnt Umber and turpentine and a no. 12 flat sable brush.

2 | ADD DETAIL
Paint the darker parts of the fur with the same brush and a mixture of Burnt Umber, Payne's Gray and Ultramarine Blue. Don't mix in any turpentine.

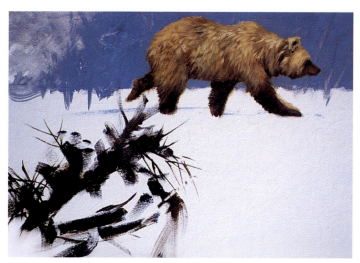

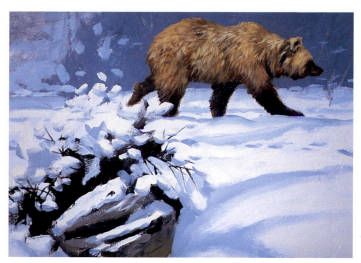

3 | PAINT BACKGROUND

Add midtones to the bear with a no. 30 flat brush and a mixture of Raw Sienna, Burnt Sienna and Titanium White. Then block in the background with a mixture of Viridian, Alizarin Crimson and Titanium White. Establish the dark shadow area of the tree in the foreground with Ultramarine Blue and Burnt Umber.

4 | LAY IN SNOW

Lay in the light areas of the snow with a no. 30 flat brush and a mixture of Titanium White and Naples Yellow. Paint the shadows on the snow wet-in-wet with a no. 30 flat and Ultramarine Blue and Payne's Gray. Paint the rock with a mixture of Burnt Umber, Payne's Gray and Ultramarine Blue. Add the clumps of snow that hang on the branches.

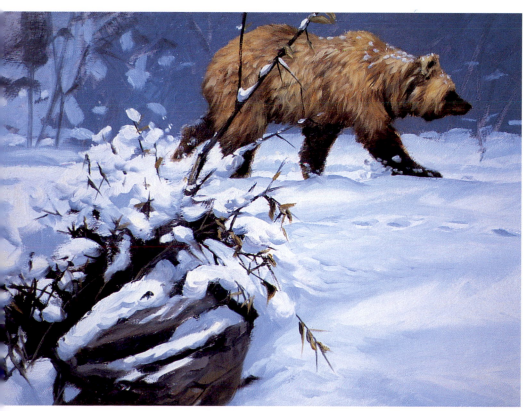

5 | ADD FINISHING TOUCHES

Add more detail to the rock and branches in the foreground with a no. 4 flat brush. Add another branch crossing the bear to bring the viewer's eye to the center of interest. Also paint some branches in the background. Add some texture to the surface of the snow with Payne's Gray, Ultramarine Blue and Titanium White. Paint snow on the branch to provide contrast between the tree and the bear, and add a few flakes of snow to the bear's coat.

Translating From Field to Studio

Doing field sketches and paintings is very important, but it's equally important to know what to do with them back in the studio. Pure plein air painting is an art form itself, but your aim is to use these paintings and sketches as reference material. Field sketches often won't mean anything until some later time. Sketching the scene rather than just taking pictures forces you to spend time studying the scene, and it will always be in your memory. A field sketch not only provides facts about an animal, bird or habitat but also triggers memories about your experience and the feel of the moment.

SKETCH BEFORE PAINTING

I drew this graphite sketch quickly as a grizzly sat in the water in Alaska. I based the painting at right on this sketch.

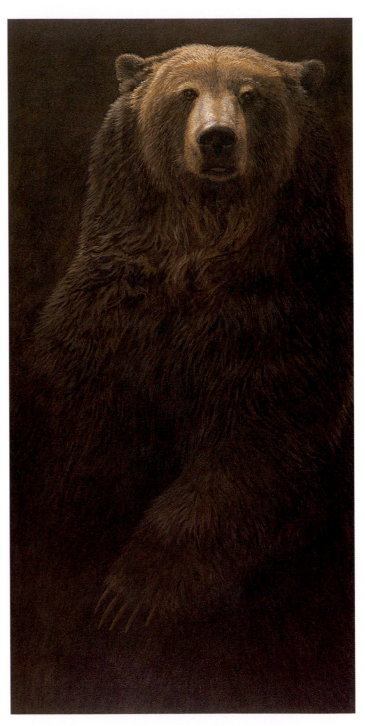

USE MINIMAL PALETTE

I based the painting at right on the above sketch but decided to make the image more mysterious by making the lower portion darker. I did this painting with a minimal palette: I painted the lighter parts of the bear's fur with Burnt Sienna and Raw Sienna. I painted the dark areas with a dark mixture of Payne's Gray, Burnt Umber and Ultramarine Blue. Then I laid a thin wash of Yellow Ochre and a wash of Burnt Sienna over the piece. Once this dried, I applied several washes of the dark mixture. After the series of washes, I emphasized the highlights, then applied another light wash of Burnt Sienna over the whole piece.

DARK MAJESTY
36" × 18" (91cm × 46cm) | Acrylic on Masonite | 1994

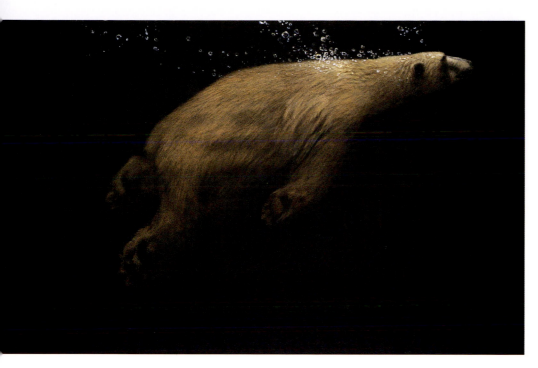

COMPENSATE FOR CONDITIONS

I did this painting after watching polar bears at a zoo. Visitors could view the bears underwater through a panel below the surface of the water. I did some field sketches and took some video. The water in the tank was very clear, but I envisioned dark Arctic water and the bear disappearing into the shadows. For the main painting, I painted the bear with Naples Yellow, Yellow Ochre and Titanium White. I painted the dark areas with Burnt Umber and Ultramarine Blue. Once the bear dried completely, I laid down a series of glazes over the whole painting with a dark mixture of Burnt Umber, Payne's Gray and Ultramarine Blue. I wiped the glaze off the bear's head and back.

WINTER WATER—POLAR BEAR
24" × 36" (61cm × 91cm) | Oil on Masonite | 1998

USE MORE THAN ONE REFERENCE

I produced several quick graphite field sketches of these ravens. I used them later as references for the painting below.

MAKE MOST OF DARK AND LIGHT

I based this painting on my field sketches and photos of the ravens. I designed the painting around a stark black image on a white background. Composition was very important in this piece. I introduced an equally dark rock with the ravens to create an abstract shape, which you can see if you squint your eyes to look at it.

COMMAND POST—RAVENS
24" × 36" (61cm × 91cm) | Oil on canvas | 1994

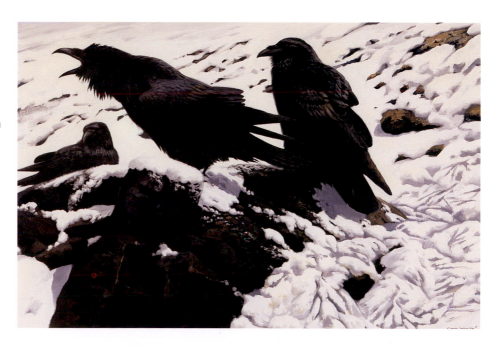

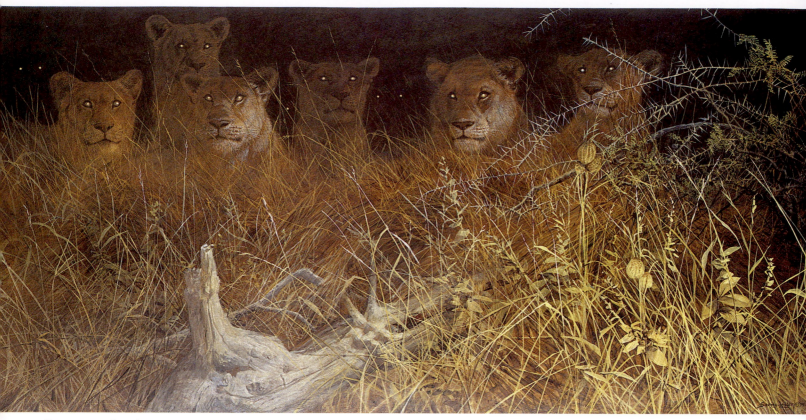

RETURN TO OLD IDEA

On a trip to East Africa, I was camping in Amboseli Park, Kenya. From camp I could see the eyes of lions shinning through the dark, illuminated by our campfire. I felt somewhat anxious but also intrigued, so I did a quick sketch by flashlight. Years later I decided to turn that sketch into a major painting. I primed a panel with my mid-gray gesso mixture. Then I painted the lions and the grass as if they were in sunlight. I laid in washes of Yellow Ochre and a dark mixture of Payne's Gray, Burnt Umber and Ultramarine Blue, then two washes of Burnt Sienna. I added the most interesting part of the scene, the highlights in the eyes, last.

NIGHT LIGHTS
24" × 48" (61cm × 122cm) | Acrylic on Masonite | 1995

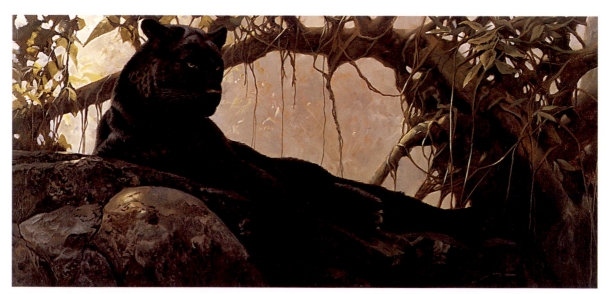

COMBINE REFERENCES

I sketched this black leopard in a zoo. I liked its sleek lines as it laid on the rock. When I returned to the studio, I adapted some of my field paintings from India to the composition I planned for a painting with the leopard silhouetted against the background. I painted a small watercolor study before starting the final painting.

INDIA DAWN
16½" × 36" (42cm × 91cm) | Oil on Masonite | 1995

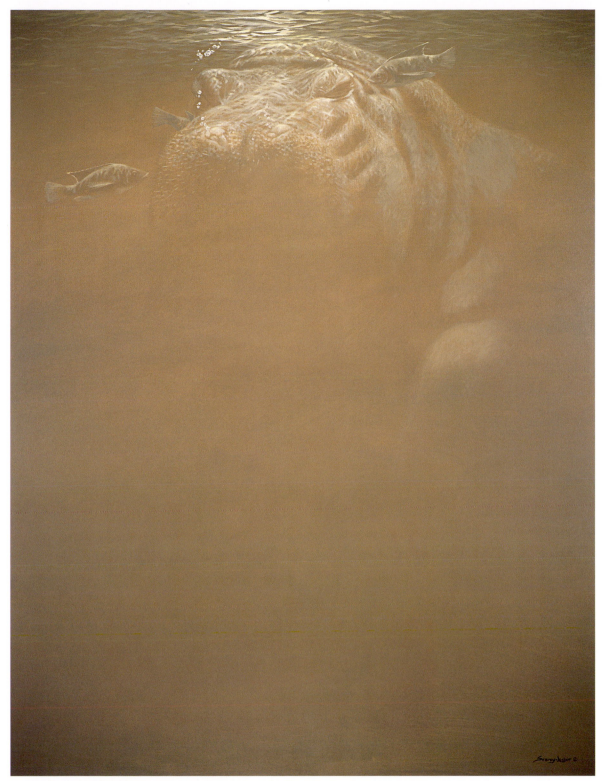

PUT IT IN CONTEXT

I did a field sketch of this hippo, who was underwater at a zoo where the water was very clear. In the wild I've only seen hippos in the muddy Mara River in Kenya, though, and this is how I wanted to portray the scene. I envisioned a painting in which the viewer could see only the highlighted parts of the hippo, the remainder of its body disappearing into the murky water. I added the fish cleaning the hippo's skin as a secondary point of interest.

MARA RIVER HORSE
60" × 48" (152cm × 122cm) | Oil on canvas | 1999

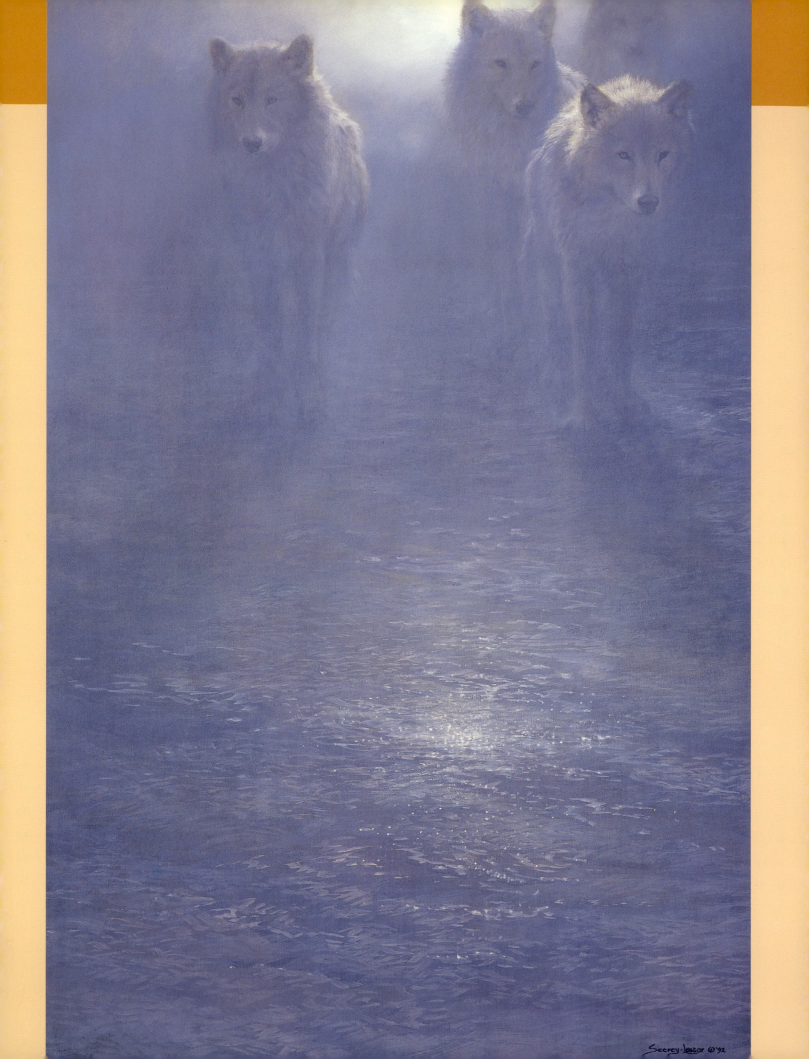

Seerey-Lester ©'92

Color and Value

Color and value are two of the most crucial aspects of any painting. Value is necessary to create depth in a painting. A gray scale, which you can buy from most art supply stores or create yourself, helps evaluate value and determine the correct one for your painting. I often use an amber photo filter mounted in a black mat the size of a regular 35mm slide to evaluate the values in a scene.

Value comes into play when creating perspective to indicate depth and bring a painting to life. One way to create perspective is through atmosphere, such as mist, dust, rain or a snowstorm. Don't be afraid to exaggerate distance in a painting. It can add depth to a piece and heighten the viewer's interest. Losing edges also helps emphasize depth and add to perspective. Hard edges bring a subject closer to the viewer; soft edges indicate distance by pushing the subject back. The subtle and clever use of color is just as vital as value and depth. Your use of color can make or break a painting. In this chapter, I'll discuss cool and warm colors, how to create them, when and where to use them and when to introduce special colors. A painting is the creation of a world over which the artist has full control. Make the most of such an opportunity!

EMBRACE HAPPY ACCIDENTS
Occasionally, happy accidents occur when painting. I did this painting in acrylic first. After I established the detail, I applied a mixture of Ultramarine Blue, Payne's Gray and Titanium White oil paints between the wolves. Unhappy with the result, I rubbed out the color with a paper towel and turpentine before the paint dried. The results, to my surprise, delighted me, so I also wiped out the highlight areas of the wolves. Then I emphasized these highlights, the frozen ice and the moonlight in the background and softened the moonlit area with dry brush strokes.

FROZEN MOONLIGHT
36" × 24" (91cm × 61cm) | Mixed media on Masonite | 1992

Painting Atmospheric Perspective in Oil

MATERIALS LIST

BRUSHES
Langnickel Royal sable series
5590 flats
 no. 12 ~ no. 16 ~ no. 30
1½-inch (38mm) house-paint-
ing brush

COLOR PALETTE
Rembrandt Artist Quality oils
*Burnt Sienna ~ Burnt Umber
~ Payne's Gray ~ Raw Sienna
~ Titanium White ~ Ultra-
marine Blue ~ Yellow Ochre*
Winsor & Newton Finity acrylics
*Ultramarine Blue ~ Payne's
Gray ~ Burnt Umber*

OTHER
white gesso

SURFACE
36" × 24" (91cm × 61cm)
Masonite

There is not a lot of distance between the bear and the willows in this painting, but you can exaggerate the atmospheric perspective and values to give depth to an otherwise flat composition.

1 | BEGIN WITH SKETCH
Prime the Masonite with a mid-gray mixture of Ultramarine Blue, Payne's Gray and Burnt Umber acrylics and gesso. Sketch in the bear, which will be the lightest value in the painting. Block in the bear's darkest areas, starting with the eyes, with a mixture of Titanium White, Payne's Gray and Burnt Umber oils and a no. 16 flat brush.

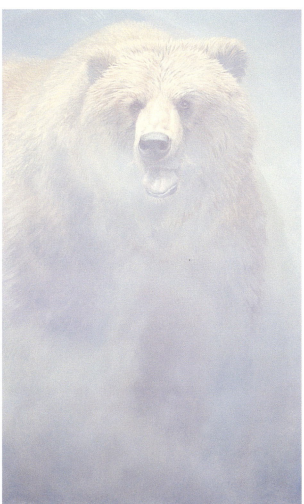

2 | BLOCK IN REST OF BEAR
Paint in the remainder of the bear using a no. 30 flat brush and mixtures of Burnt Sienna, Burnt Umber, Raw Sienna and Titanium White. Keep the value light and the hues cool. Drybrush in the bear's breath with a 1½-inch (38mm) house-painting brush and a mixture of Payne's Gray and Titanium White.

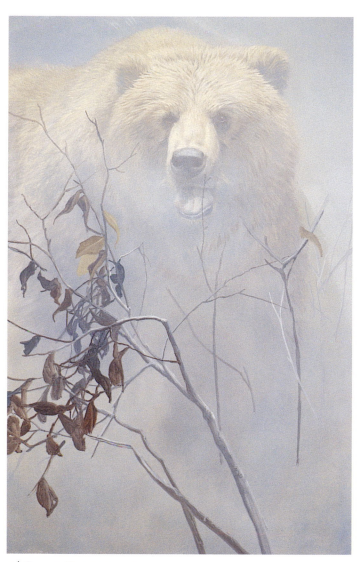

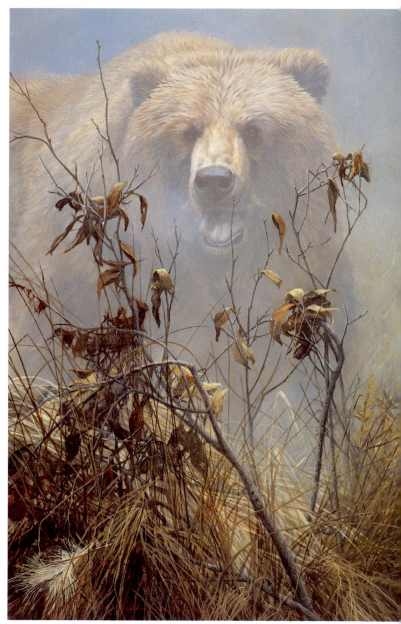

3 | START FOREGROUND

Lay in the willow branches and dead leaves with the edge of a no. 12 flat brush and a mixture of Burnt Umber, Ultramarine Blue and Payne's Gray. Paint the dead leaves with a mixture of Yellow Ochre and Burnt Sienna. Add Burnt Umber and a touch of Payne's Gray to this mixture to paint the darker leaves and those in shadow.

4 | ADD FINISHING TOUCHES

Soften the background with dry-brushed cool colors to push it back, and paint the foreground and midground with warmer colors and sharper details to make them appear closer to the viewer. Paint in the midground foliage with a no. 16 flat and warm colors: Yellow Ochre, Burnt Sienna, Burnt Umber and Titanium White. Don't make any of these values darker than the foreground or lighter than the background. Paint additional willow branches over the head and mouth of the bear to add more depth. Paint the grasses in the foreground with a no. 16 flat brush and a mixture of Yellow Ochre, Raw Sienna and Titanium White.

GRIZZLY IMPACT
36" × 24" (91cm × 61cm) | Oil on Masonite | 1993

Gaining and Losing Edges

"Losing edges" means softening the outline of an object. You can do this several ways when painting in oil. If painting wet-in-wet, drag the paint from the object into the background, then drag the background color into the object. Go over each area with only one stroke. If you repeat the stroke while the paint is wet, you might drag too much paint and muddy both the object and the background. You also can blend the object into the background while both are wet by repeating strokes back and forth in the same direction as the line you want to blend.

Once an oil painting is dry, you can drybrush the edges of an object to soften them. Make a mixture that is close to the background color or a bit lighter without any medium. Lightly scrub this mixture onto the canvas over the edges you want to soften.

In acrylic painting you can achieve soft edges with a series of washes rather than blending after you apply the paint as you do in oil painting. Build the subject, background and their surroundings all at the same time. Don't concern yourself with the outline of the subject and don't be afraid to overlap it with the background. Overlapping these washes is what ultimately creates the soft edges.

DRAG COLORS
Hold a flat brush between your forefinger and thumb and drag it across the surface.

The middle-ground stones have slightly softer edges. For this effect, blend the area with the immediate background while the paint is still wet.

I've blended the edges of the stone in the background even more.

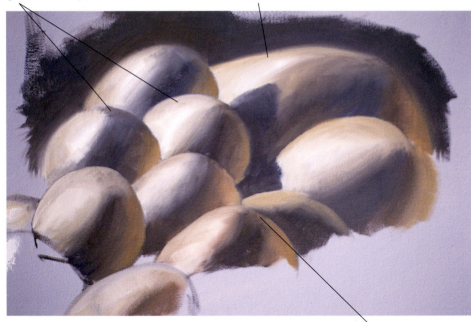

BLEND INTO BACKGROUND
The softer an object's edges, the farther back in the picture it appears. Although the stones are round, those in the foreground have a harder edge. The stone in the background on the right, although the largest, seems farthest away because I've blended the edge so much.

An object with a hard edge appears to be closer to the viewer.

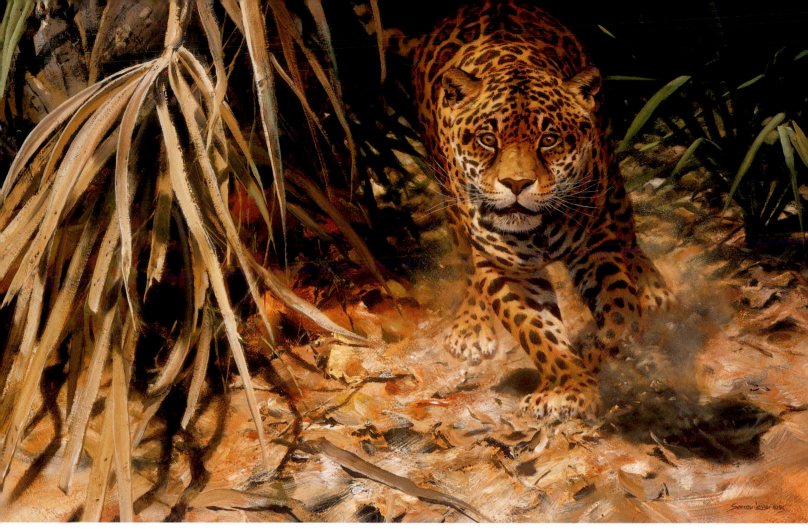

Use Depth to Encourage Motion

I used hard and soft edges to indicate depth here. I softened the edges of the background elements on the right to push them back. The edges on the jaguar's hind legs are softer than the edges on his forelegs. I painted hard edges on the palm fronds in the foreground on the left to bring them forward. These fronds and the cat's head are the sharpest elements in the painting. The viewer gets a great sense of the distance the jaguar has traveled and thus the speed at which it's running.

INTO THE CLEARING—JAGUAR
24" × 36" (61cm × 91cm) | Oil on canvas | 1996

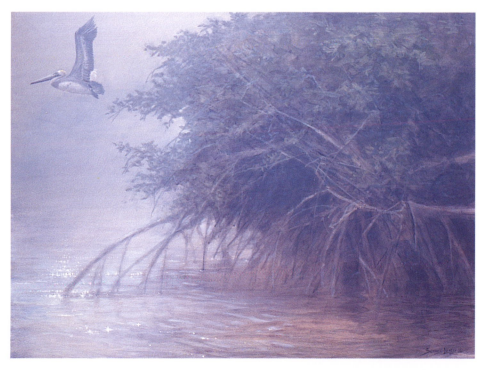

Drawing With Brush

Don't always worry about drawing a base sketch for your painting. Be confident to just draw with your brush sometimes. After priming the Masonite, I established the dark shadow areas with a thin wash of Payne's Gray and Raw Sienna. I established the branches with almost pure white gesso. Then I added detail to the lighter areas of the mangrove foliage and painted the water. The branches in the foreground on the right are clearer and darker, giving the illusion that this part of the mangrove is closer. The edges, though, are lost, or softened, to appear farther away. This gives the painting depth and emphasizes the brown pelican.

MANGROVE MIST—BROWN PELICAN
18" × 24" (46cm × 61cm) | Acrylic on Masonite | 2001

Painting Value in Acrylic

Establishing values well in a painting is a must. Understanding them and how they work is vital to the success of any painting. Sometimes you can look at a scene in a certain light and swear that all of the values are the same. This is just an illusion. Use a gray scale, which you can buy at most art supply stores, to establish values until you get the hang and feel of doing it yourself. Paint the lightest, then the darkest values first. The values between will become evident. Remember that the darkest shadows in the background or middle ground will never be as dark as the shadow in the foreground.

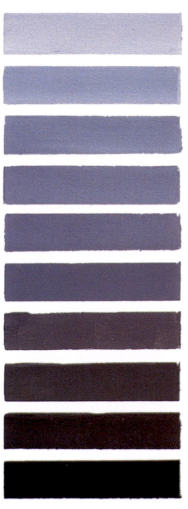

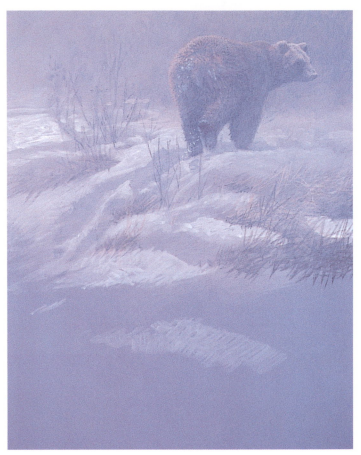

GRAY SCALE
This gray scale's base color is a mix of equal parts Burnt Umber, Ultramarine Blue and Payne's Gray, the standard mixture I use for darks. Keep adding white to make the colors progressively lighter. The fifth bar from the bottom matches my mid-gray primer value.

1 | ESTABLISH SHAPES
Prime the Masonite with a mid-gray mixture of Ultramarine Blue, Payne's Gray, Burnt Umber and white gesso. Establish the shape and shadow areas on the bear with a mixture of Payne's Gray, Burnt Umber, Raw Sienna and gesso. Also establish the background values now. Paint the bushes and branches in the background with a ½-inch (31mm) flat brush and Payne's Gray and Raw Sienna. Then push the background back with a wash of gesso and Payne's Gray. Block in the snow with a ½-inch (31mm) flat brush and pure gesso. Add a mixture of Raw Sienna, Burnt Sienna and gesso to the bear with a 1¼-inch (31mm) flat brush. Follow that with a light wash of Yellow Ochre and then a wash of gesso.

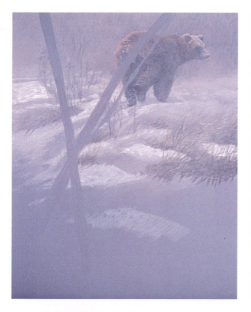

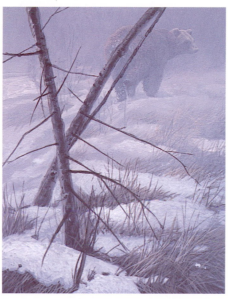

2 | PAINT FOREGROUND

Paint in the trees in the foreground with a ½-inch (12mm) flat brush and the priming mixture from step 1 and some more Payne's Gray. These will become the darkest value in the piece, but at this stage you're just establishing their locations. You established the lightest values in the background in step 1 and the darkest values in the foreground in this step. Now you can paint the rest of the values within this range.

3 | DEVELOP SURROUNDINGS

You've already established the background and midground values, so don't change the values as you paint. Go over the trees again and paint some of their branches with a ½-inch (12mm) flat brush and Ultramarine Blue and Burnt Umber. Paint the grass in the foreground with Raw Sienna and the dark areas between the grass with Burnt Umber and Payne's Gray.

4 | ADD FINISHING TOUCHES

Add more branches to the trees with a ½-inch (12mm) flat brush, placing them carefully to aid the composition. Paint the grass and saplings in the foreground in the same value. Paint the dark areas between the grass with a mixture of Payne's Gray, Ultramarine Blue and Burnt Umber. Splatter the whole painting by dragging your forefinger across a stiff toothbrush loaded with gesso. Make sure the paint is very wet.

TUNDRA FLURRY—GRIZZLY
16" × 12" (41cm × 30cm) | Acrylic on Masonite | 2001

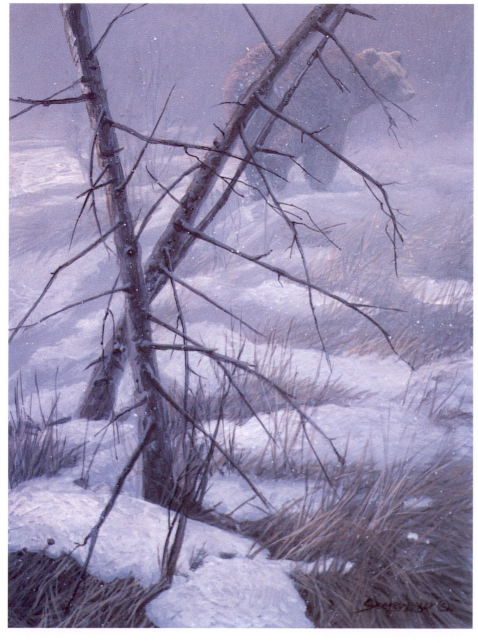

Getting the Right Value and Hue

Once you've established what values to use in a painting, evaluate the hue. Subtle changes in hue can be very pleasing to the viewer's eye. Just as values get lighter toward the background and darker toward the foreground, hue, no matter what color you're using, becomes cooler toward the background and warmer toward the foreground. If you're painting trees, for example, add blue and white to a green mixture to paint background trees, and add yellow and Burnt Sienna to paint warmer foreground trees. Carefully mix the hue on your palette before painting.

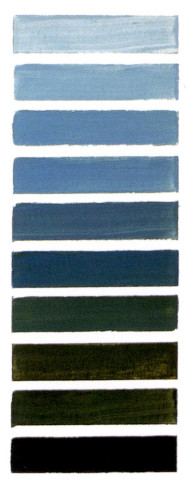

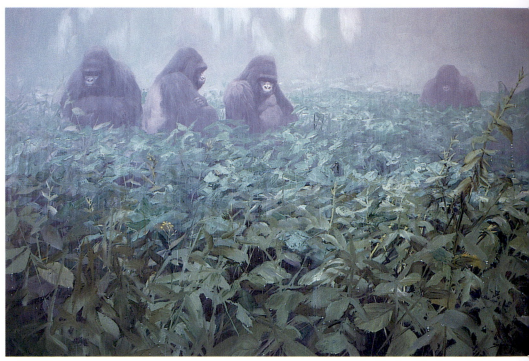

PAINT WITH IMPASTO STYLE

I painted these gorillas with a minimal palette, mostly Payne's Gray, Alizarin Crimson, Viridian and Titanium White. I used other select colors in certain areas. I painted the gorillas first, then the background and then the darkest darks in the foreground with an impressionistic technique. I painted the foliage in the middle ground and foreground with an impasto technique: I didn't paint each leaf separately but rather created an illusion of the foliage with thick paint and single, broad brushstrokes with a no. 30 flat brush. When the thick paint dries, it leaves a shadow that adds form to the mass of foliage. I added the saplings in the foreground with a darker value to add perspective to the scene. I added raindrops to the leaves with a liner brush.

In a painting dominated by one color, introducing a color used nowhere else can bring the piece together. In this piece, I included the yellow flowers to add interest and give the viewer's eye relief from the other foliage.

RAIN MEN—MOUNTAIN GORILLAS
24" × 36" (91cm × 61cm) | Oil on canvas | 2000

GREEN SCALE

I painted this green scale for the painting at right. The scale is only a guide and can differ for other paintings. Notice how the hue changes from cool at the top and warm at the bottom. I used the hues at the top of the scale for background colors and the hues at the bottom for foreground colors.

Painting Panthers in Acrylic

MATERIALS LIST

BRUSHES

Pro Arte series 106
⅜-inch (10mm) flat ~ ¾-inch (19mm) flat
2-inch (51mm) house-painting brush

COLOR PALETTE

Winsor & Newton Finity acrylics
Burnt Sienna ~ Burnt Umber ~ Naples Yellow ~ Payne's Gray ~ Raw Sienna ~ Titanium White ~ Ultramarine Blue ~ Yellow Ochre

OTHER

white gesso

SURFACE

18" × 36" (46cm × 91cm) Masonite

Establish the values you'll use in this painting, a light background grading to a darker foreground, following the scale below. The panthers should match the midground value. After you've established values, you can play with warm and cool hues and add details.

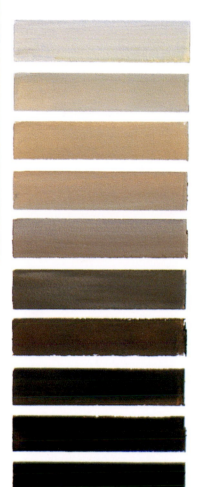

50 percent Titanium White, 25 percent Burnt Umber, 25 percent Yellow Ochre

40 percent Yellow Ochre, 30 percent Burnt Umber, 30 percent Titanium White

equal parts Burnt Umber, Yellow Ochre and Titanium White

60 percent Burnt Umber, 20 percent Yellow Ochre, 20 percent Titanium White

70 percent Burnt Umber, 15 percent Yellow Ochre, 15 percent Titanium White

80 percent Burnt Umber, 10 percent Yellow Ochre, 10 percent Titanium White

85 percent Burnt Umber, 10 percent Yellow Ochre, 5 percent Titanium White

90 percent Burnt Umber, 7 percent Yellow Ochre, 3 percent Titanium White

100 percent Burnt Umber

90 percent Burnt Umber, 3 percent Payne's Gray, 3 percent Burnt Umber and 3 percent Ultramarine Blue

BROWN SCALE

This brown scale, similar to the gray scale on page 66 and the green scale on page 68, moves from light to dark and cool to warm. The colors change a bit for different paintings, but the value/hue relationship between the colors within each scale remains the same. Replicate this scale using the percentages of acrylic paints listed above, and follow the scale as you work on this demonstration.

1 | BLOCK IN PANTHER

Prime the Masonite with a mid-gray mixture of Ultramarine Blue, Payne's Gray, Burnt Umber and gesso. Draw a base drawing of the panther and its cub. Loosely block in the cats with a ¾-inch (19mm) flat brush and a mixture of Burnt Umber and Payne's Gray, working transparently as if with watercolor. Don't use any gesso or opaque pigments until later.

2 | ESTABLISH BACKGROUND VALUE

Finish blocking in the cub and establish the background value with a darker mixture of Payne's Gray, Ultramarine Blue and Raw Sienna. Add more weight to the cat with a ¾-inch (19mm) flat brush and Payne's Gray and Burnt Umber, still using transparent colors. Highlight the panther with a ⅜-inch (10mm) flat brush and a mixture of Naples Yellow and gesso, keeping the light source at the upper right in mind.

3 | ADD HIGHLIGHTS

Emphasize the highlights on the cat and the cub with a ⅜-inch (10mm) flat brush and Naples Yellow and gesso, giving more detail to both. Apply a wash of Payne's Gray to the whole painting with a 2-inch (51mm) house-painting brush. After this wash dries, apply a wash of Yellow Ochre over the whole painting. Then apply a wash of Payne's Gray and emphasize the highlights again.

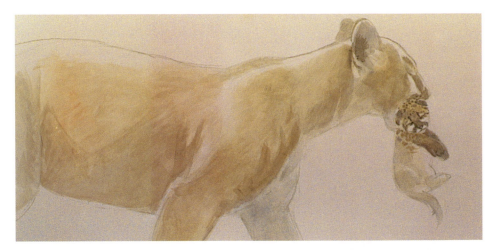

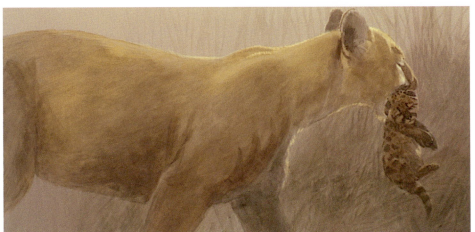

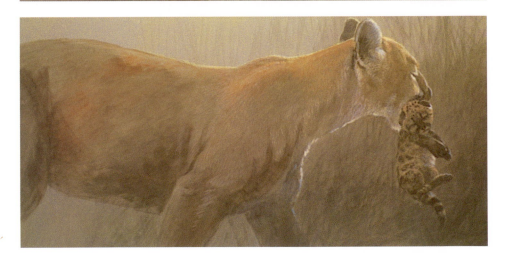

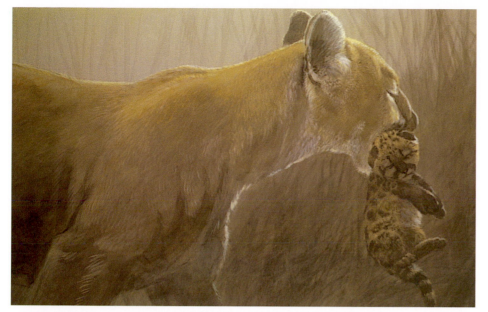

4 | ADD DETAILS

Now that you've established the values, add detail to the **panther's fur using lighter, warmer** hues. Also apply **more detail to the cub and** strengthen its values. A cub's fur is longer than an adult's fur, so use longer brushstrokes here.

5 | APPLY WASHES

Apply a mixture of Yellow Ochre and gesso between the grasses in the background to provide a low light. Then apply a wash of Burnt Sienna to the **whole painting**. Again add more weight to the panther with a mixture of Burnt Umber and Burnt Sienna. Emphasize the highlights on the cat's head, under its neck and on its chest and forelegs. Add some foreground grass with a ⅜-inch (10mm) flat and a mixture of Yellow Ochre, Naples Yellow and gesso.

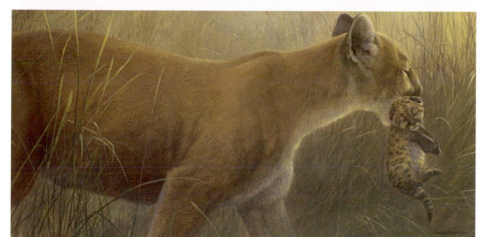

6 | ADD FINISHING TOUCHES

The cats should match the midground value, so the darks in the foreground grasses should be the darkest value of your painting. Paint these with a mixture of Burnt Umber and Payne's Gray. Paint the rest of the grass with a ⅜-inch (10mm) flat brush. Use the tail edge of your brush and, keeping your arm stiff, move it at the shoulder only; don't bend your wrist or elbow. Painting with a straight arm yields clean, sharp lines.

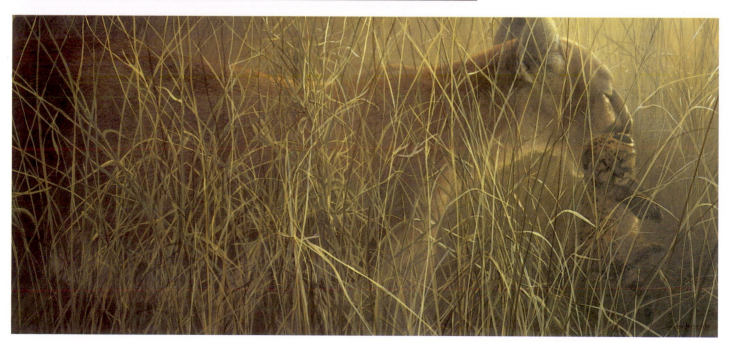

FLORIDA DAWN
18" × 36" (46cm × 91cm) | Acrylic on Masonite | 1993

71 |

Putting Principles Into Practice

Besides atmospheric perspective, you can use color and value to add impact to a painting's lighting, enhance the movement in a painting, add a secondary point of interest or lead the viewer's eye through a painting.

ESTABLISH RANGE OF VALUES FIRST

Although the overall color of this painting is warm, the hues still range from warm to cool. Because of the low sunlight, the background shadows are cooler and lighter than the midground and foreground. After blocking in the cow moose, I added the cottontails in the foreground to establish my range of values.

LADY OF THE MIST
12" × 24" (30cm × 61cm) | Oil on canvas | 1985

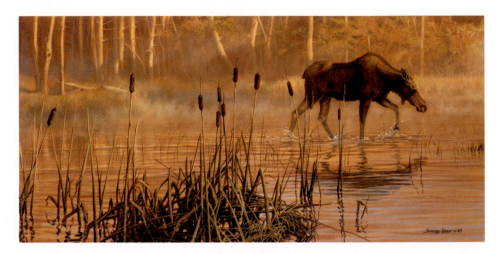

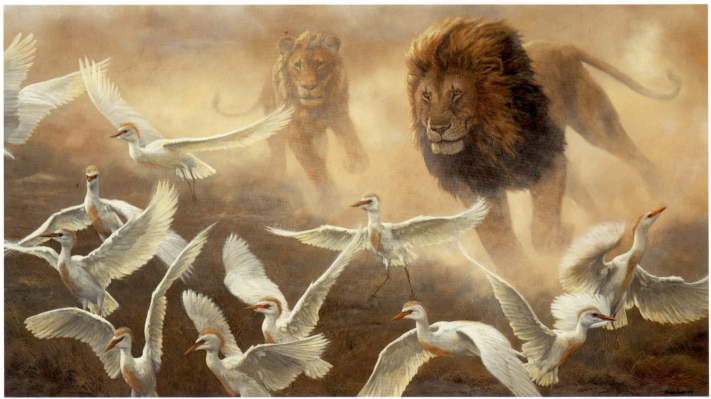

WIDER RANGE INDICATES GREATER DEPTH

I painted both of the lions first, using values that would suit their positions in the painting. Then I blocked in the egrets. Once the paint dried, I laid in the dusty background color and dragged it over the lions. Then I drybrushed some of the background color over the lions to soften the edges. I painted the foreground and gave the egrets more detail, although I softened the edges of their wings. Finally, I added highlights to the lions and birds. Not only does this painting provide an extreme example of receding values and hues, I exaggerated this effect by applying plenty of detail in the foreground and practically none in the background. This gives the impression of greater depth and distance, which adds to the lion's speed.

SUDDEN RUSH—CATTLE EGRETS WITH AFRICAN LIONS
36" × 60" (91cm × 152cm) | Oil on canvas | 1991

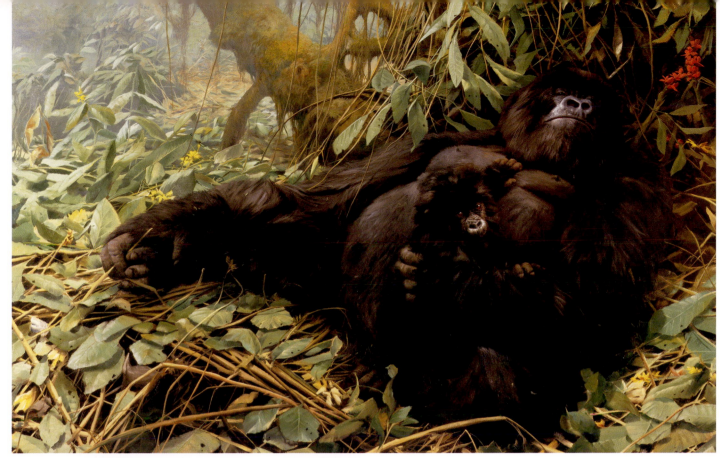

STEER COMPOSITION

I did this painting wet-in-wet using an impasto technique. I painted the gorilla and her young as a solid mass of Burnt Umber, Payne's Gray and Ultramarine Blue. Before that dried, I painted in both of their eyes. I dragged the youngster's fur across the body of the mother to soften the edges. I painted the foliage loosely so it wouldn't look contrived. I painted the dark negative space between the leaves to define the leaf shapes and plant stems. Then I emphasized individual plants. I added yellow flowers in certain areas and drybrushed a mixture of Titanium White and Payne's Gray over the background for atmospheric perspective. Most importantly, I introduced a pinkish red flower behind the gorilla's head. Rather than creating an entirely new point of interest with a new color, as in the example at left, this flower's unique color simply steers the viewer's eye through the composition.

CRADLE OF HOPE
48" × 72" (122cm × 183cm) | Oil on canvas | 1996

ADD SECONDARY POINT OF INTEREST

Although the wolf is the main subject, I pushed it back behind the snow-laden branches. Sometimes you'll need to introduce something new or unexpected to create more interest. An interesting light source or a color not used elsewhere in the painting often works well. This basically monochromatic painting needed an extra spark of interest. By adding the rising sunlight to just the one area, I've made it the focal point so the viewer will "discover" the wolf next. I've given the viewer more interesting things to see without overcrowding the painting.

DAWN'S EARLY LIGHT
60" × 48" (152cm × 122cm) | Acrylic on canvas | 1999

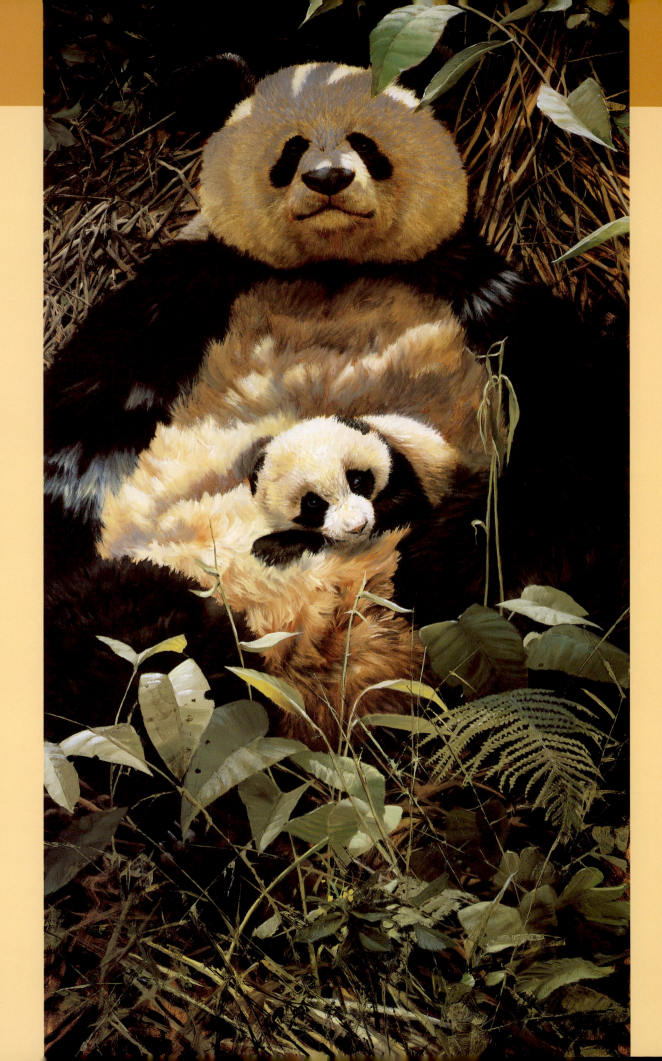

Painting the Subject

In wildlife art the subject is the most important aspect of a painting. Accuracy is of the uppermost importance. No matter how well you render the rest of the piece, if you don't paint the main subject accurately, the painting will fail. Even in loose and impressionistic paintings, the illusion of fur or feathers must read properly. In this chapter you'll see various techniques for painting birds and animals accurately in oil and acrylic. No set technique always works; each painting requires specific attention and different methods. Carefully study the elements of your subject before starting a painting. Every animal has different fur characteristics. For example, the fur on a grizzly behaves like a landscape. The short hair on the muzzle and head are like grasslands, and the fur on the hindquarters is more like a tree line. Animals' eyes also have great impact on a painting. If the eyes are wrong, the painting just won't work.

CELEBRATING HUA MEI
48" × 24" (122cm × 61cm) | Oil on canvas | 2000

Portraying Your Subject

Portraying your subject accurately really is a simple process. Apply a base coat of a color that suits the mood you want to convey. Then block in the basic shape of your subject. Establish the lights and darks, paying attention to the subject's muscle structure. Paint a few layers of fur or feathers, covering each one with a thin wash to push it back and thus give the animal and painting depth. Then work on the details, adding highlights and painting the animal's expression. Pay particular attention to the subject's eyes as you finish up the painting. It's that simple.

HOLD ON TO SKETCHES
I did this field sketch of a male lion's head in 1980. I turned it into the painting on page 77 twenty years later.

BLOCK IN
I primed my canvas with thick gesso and let it dry. Then I applied a thin wash of Burnt Sienna acrylic paint over the whole canvas and lifted some of the wash with a paper towel before it dried. After drawing a light charcoal sketch, I blocked in the head with thin glazes of Burnt Umber and Burnt Sienna oils.

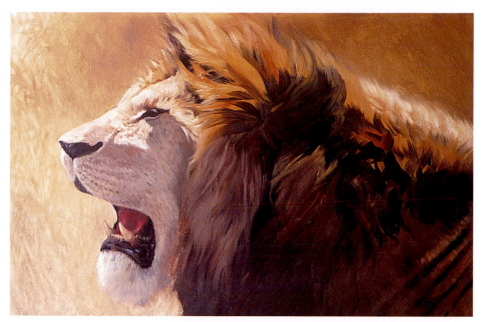

ESTABLISH LIGHTS AND DARKS

I established the dark shadow areas in the lion's mane and added details to the eyes, nose, muzzle and mouth.

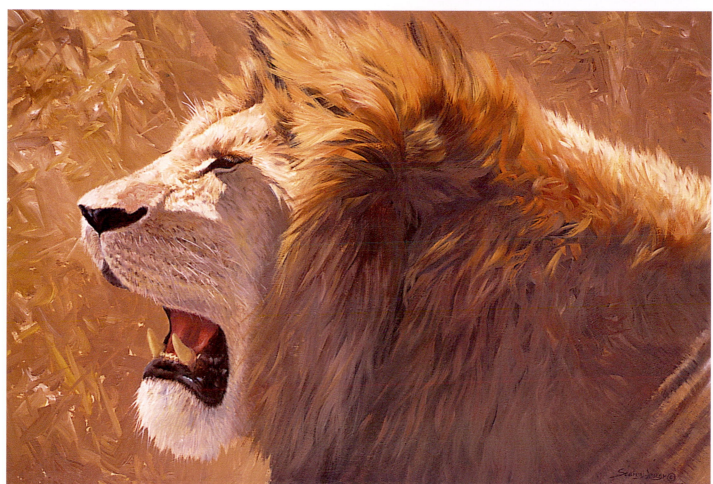

FINISH UP

I added lighter fur over the dark shadow areas of the mane. I painted the background in an impressionistic style so it wouldn't interfere with the subject in the foreground. I dragged the mane's finishing touches into the background to soften the edges.

QUIET MAJESTY
24" × 36" (61cm × 91cm) | Oil on canvas | 2000

Capturing Your Subject's Character

The subject's eyes are the single most important element in any painting. Think of them as glass balls or marbles. The light that reflects on the top of the eye is refracted at the base. Reflected light also appears under the eye. Besides the physical attributes, try to bring out the character of the wildlife through its eyes. The shape of the brow especially helps indicate expression and character. Study the variations in the eyes of different animals and birds below. Also make a point to study eyes carefully in the field. It will pay off.

GREAT HORNED OWL
This owl gets its character from the deep, sweeping brow that leads up to the ear tufts. Its bright yellow eye also has a heavy upper eyelid and a distinct pupil.

GOLDEN EAGLE
The eagle's domineering characteristic is its prominent brow. The eye itself is a brownish color and has a prominent pupil. It's set deep and moves distinctively in the socket.

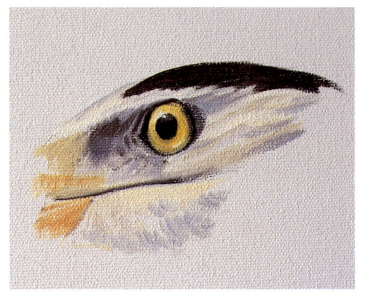

GREAT BLUE HERON
This heron has a prominent yellow eye and dark pupil. The eye pivots dramatically. Make sure you get the perspective right to correctly indicate the direction in which the bird is looking.

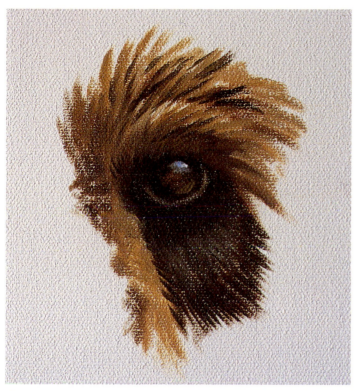

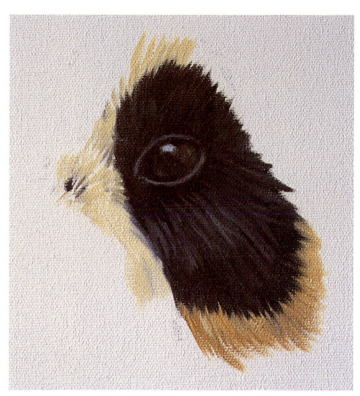

GRIZZLY

The grizzly has heavy fur on its brow, a small eye and darker, shorter fur under the eye. Grizzlies eyes hold the same expression for all moods.

GIANT PANDA

Pandas' dark eye patches vary slightly in shape for each panda. Because the black patches are round, people often don't notice that panda eyes are actually almond shaped. Their dark brown, almost black, eyes also have subdued highlights.

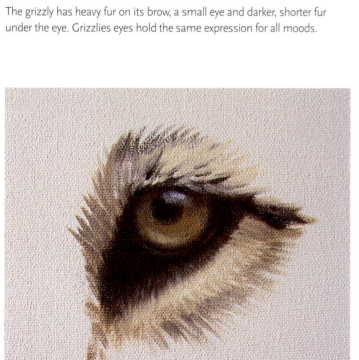

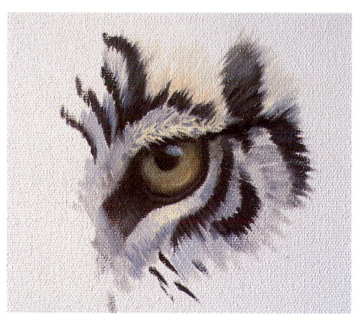

WOLF

The wolf's eyes are set deep and high beneath its prominent brow. The lower lid and lid pocket are dark with an extended teardrop shape, adding to the wolf's typically sinister expression.

TIGER

The white Bengal tiger's eye is similar to yellow tigers' eyes. Below the dark lower lid is a white fur crescent that helps form the eye's long teardrop shape. The tiger's eye is one of the most expressive of the big cats. The pupil is round, unlike the oval pupil of domestic cats.

Studying Fur

Rendering fur and feathers properly should be a fundamental skill for all wildlife painters. If you don't paint them correctly, the painting will fail. You'll practice fur painting techniques in the demonstrations on pages 84 through 89. Once you understand the technique and you've studied your references and the type of fur you want to paint, the rest is easy. Always remember, though, that the fur is just the surface of the animal. Also study the anatomy beneath, particularly the muscle structure, to get accurate results.

Accuracy Is Important

This painting features Masai figures, but it also shows examples of both fur and feathers. In Masai tradition, a young warrior kills a male lion on his path to manhood to earn the prized title "the lion killer." The warrior then makes the lion's mane into a headdress. They also make headdresses out of ostrich feathers. I painted the headdresses loosely, but I used specific and deliberate brushstrokes for the fur and feathers. It's always important, especially in a painting like this, to paint the fur accurately so the viewer can understand the scene.

Fur and Feathers—Masai
Ceremony
48" × 24" (122cm × 61cm) | Oil on canvas | 2001

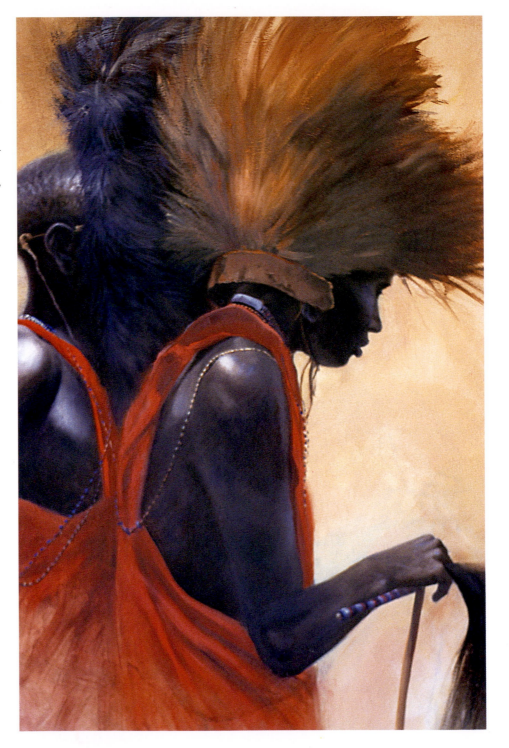

POLAR BEAR

A mixture of Yellow Ochre and Naples Yellow makes a good base color for polar bear fur. To paint this fur, alternate painting individual hairs and laying down washes to push them back. For this example, I painted a layer of hair with gesso, then laid down a wash of Yellow Ochre. Then I painted more hairs with gesso and laid down a wash of Raw Sienna. I continued this pattern, also laying a wash of Burnt Sienna with Naples Yellow and a final wash of gesso.

WOLF

The wolf's fur is grizzled like the grizzly bear. Paint the hairs with an almost crosshatching technique. Lay down a base color with a mixture of Payne's Gray and Burnt Umber. Apply the dark areas first with Burnt Umber and Ultramarine Blue, making a wavy line from right to left with the edge of a flat brush. Repeat these brushstrokes with gesso, overlapping the previous strokes to imitate a crosshatched look. Apply a wash of Burnt Umber, repeat the individual brushstrokes, and then apply a wash of Payne's Gray.

LEOPARD

The leopard's fur is finer than the polar bear's fur, so I used shorter brushstrokes to paint it. Lay down a base coat of Yellow Ochre. Then paint the rosette pattern with Burnt Umber and Ultramarine Blue. Paint the centers of the rosettes with Burnt Sienna. Then indicate the direction of the fur with gesso and follow these brushstrokes with successive washes.

CHEETAH

The cheetah's spot pattern differs notably from the leopard's spots. The cheetah has large solid spots interspersed with smaller spots and a lighter coat. Use Naples Yellow as a base color and paint the fur the same way you would paint leopard fur. When the other washes dry, apply a wash of gesso over the highlight areas.

Painting Fur

Now that you've studied different kinds of fur, the painting part should be easy. You just need to know the kind of brushstrokes to use to get the look you need. Study these examples to see how I painted each kind of fur.

CROSSHATCHED FUR

Note the brush technique that looks almost like crosshatching. I also painted the background with random simplicity. The backlighting helps the viewer pay more attention to the subject than to the background. I used only three brushes for this painting: a ⅜-inch (10mm) flat, a ½-inch (12mm) flat and a 1¼-inch (31mm) flat.

SEEKING ATTENTION
18" × 36" (46cm × 91cm) | Acrylic on Masonite | 1993

FUR BRUSHSTROKES

This oil painting shows the different brushstrokes I use for different lengths of fur and different textures. The cubs' fur and manes are slightly longer than their mother's. Younger cubs than the ones in this painting have very gray manes. Note how the perspective of the spots helps indicate the cheetahs' muscle structures.

KENYAN FAMILY—CHEETAHS
24" × 36" (61cm × 91cm) | Oil on canvas | 1983

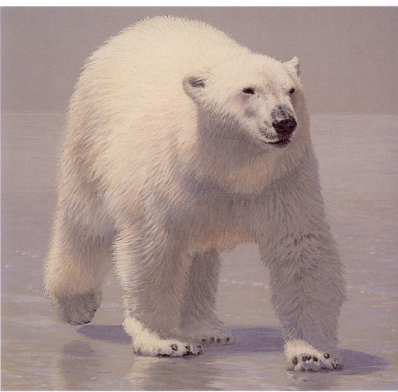

POLAR FUR

I did this small acrylic study in preparation for a larger piece. Notice the individual brushstrokes for the fur and the reflected light on the shaded areas of the bear's belly and neck.

ICE WALKER
9" × 12" (23cm × 30cm) | Acrylic on Masonite | 1993

USE SHORT STROKES FOR SHORT FUR

This small acrylic painting of a cougar shows brushstrokes for shorter fur. Alternate layers of fine strokes with a ⅜-inch (10mm) flat brush with successive washes. Introduce light on the front of the cougar, and then wash its hindquarters into the dark background.

EVENING SHADE
9" × 12" (23cm × 30cm) | Acrylic on Masonite | 1993

DIFFERENT FUR, SAME TECHNIQUE

Gorilla fur is very different from the fur of other animals, but the principles for painting it remain the same. Use short brushstrokes around the head and neck. Let the strokes get longer and flow more as you move into the shoulders and arms. Pay attention to the fur's direction.

THE THINKER
24" × 36" (61cm × 91cm) | Oil on canvas | 1992

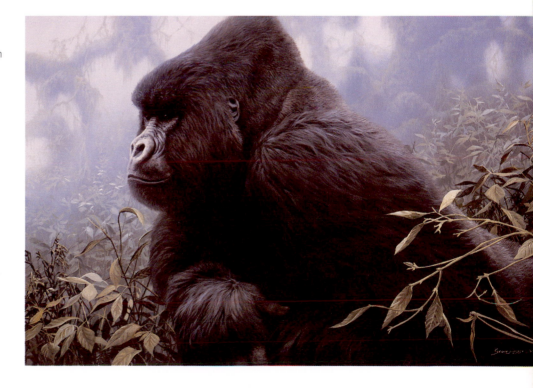

Painting Grizzly Fur in Acrylic

MATERIALS LIST

BRUSHES
Pro Arte series 106 flats
⅜-inch (10mm) ~ 1-inch
(25mm)

COLOR PALETTE
Winsor & Newton Finity acrylics
*Burnt Sienna ~ Burnt Umber
~ Payne's Gray ~ Raw
Sienna ~ Ultramarine Blue
~ Yellow Ochre*

OTHER
white gesso

SURFACE
Masonite

You'll paint the back of a grizzly bear in this demonstration. To paint realistic fur, not only do you need to study the animal you want to paint and use the right brushstrokes, but you also need to study the animal's body and muscle structure. I've drawn the rest of the bear in on step 9 on page 86 so you can see the part of the bear you're painting.

1 | UNDERPAINT FUR
Prime a Masonite panel with a mid-gray mixture of Payne's Gray, Ultramarine Blue, Burnt Umber and gesso. Let the primer dry completely. Paint a patch of fur representing a grizzly's back with a 1-inch (25mm) flat brush and a mixture of Burnt Umber and Payne's Gray. Soften the top of the patch where you'll paint lighter fur later.

2 | ESTABLISH DIRECTION
Apply a mixture of opaque gesso and a little Burnt Umber over the dark base with a ⅜-inch (10mm) flat brush. Establish the correct direction of growth and length of the fur.

3 | PROVIDE DEPTH

When this has dried completely, apply a thin wash of Burnt Umber over the patch of fur with a 1-inch (25mm) flat brush. This tones down the brushstrokes and eventually will provide depth. Use clean, clear water each time you lay down a wash. Let the wash dry thoroughly.

4 | OVERLAP STROKES

Paint another layer of fur with pure, opaque gesso and a ⅜-inch (10mm) flat brush. Maintain the general structure—the flow and direction—of the fur, but slightly overlap the previous layer of strokes to create new areas of fur. Allow this to dry.

5 | APPLY THIN WASH

Apply a thin wash of a mixture of Burnt Sienna and Raw Sienna over the patch of fur with a 1-inch (25mm) flat brush to subdue and push back the brushstrokes from step 4. Again this gives a feeling of more depth.

6 | ADD MORE FUR

Apply more fur with a ⅜-inch (10mm) flat brush and pure, opaque gesso. Again, don't follow the previous brushstrokes exactly. Change the direction of the fur just slightly, but continue to follow the basic structure you established in step 2. Allow the gesso to dry.

7 | APPLY ANOTHER THIN WASH

Apply another thin wash with a mixture of Raw Sienna and Yellow Ochre with a 1-inch (25mm) flat brush.

8 | HIGHLIGHT FUR

This time apply pure, opaque gesso only at the top of the patch with a ⅜-inch (10mm) flat brush. This will be the lightest area on the grizzly's back.

9 | APPLY LAST WASH

After the gesso from step 8 dries, apply one more thin wash of Burnt Sienna with a 1-inch (25mm) flat brush. This makes the fur on the bear's underside darker and subdues the rest of the fur.

Painting Panda Fur in Acrylic

As you work through this demonstration, concentrate on blending the fur into the background using soft edges. You always need to paint fur accurately to make an animal itself believable. But its habitat is as much a part of the animal as its own physical characteristics.

1 | SKETCH SUBJECT

Prime the Masonite with a mid-gray mixture of Ultramarine Blue, Burnt Umber, Payne's Gray and white gesso. Draw a light charcoal sketch of the pandas. Block them in with a light wash of Payne's Gray and a ¾-inch (19mm) flat brush. Don't outline the animals; just gently and lightly brush in the fur.

2 | PAINT BACKGROUND

Add some Burnt Umber over the Payne's Gray. Apply pure gesso thinly to the heads of the pandas and the belly of the adult. Then apply a thin wash of Raw Sienna and Burnt Umber to the shadow areas of the white fur with a ⅜-inch (10mm) flat brush. Paint the background with a light wash of Payne's Gray and Raw Sienna. Before it dries, lift off some of the paint with a 1-inch (25mm) flat to give the illusion of foliage. Use random brushstrokes so it won't look contrived. Let the background overlap the panda a bit to soften the edges.

3 | ADD DETAIL TO FACES

Add more Payne's Gray and some Raw Sienna to the background with a 1-inch (25mm) flat brush. Add a little more detail and dark fur to the facial features with the corner of a ⅜-inch (10mm) flat brush and a mixture of Burnt Umber and Ultramarine Blue.

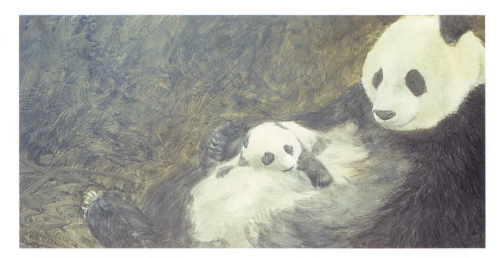

4 | APPLY WASHES

Lay a thin wash of Raw Sienna on the background. Apply a dark mixture of Ultramarine Blue, Payne's Gray and Burnt Umber to the mother's fur. Using a 2-inch (51mm) house-painting brush, apply a very light wash of the same, dark mixture over the whole painting. Follow this with a light wash of Payne's Gray. Then lay in a wash of Yellow Ochre and Burnt Sienna to provide a warm undercoat for later steps.

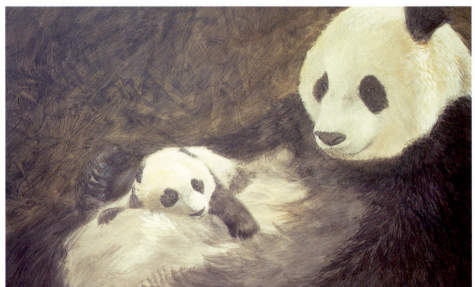

5 | REWORK

Rework the background to look like the inside of a large tree trunk, a more appropriate situation for a mother and baby than a cave. Apply a wash of a mixture of Naples Yellow and Yellow Ochre over the light fur areas of the pandas with a 1¼-inch (31mm) flat brush.

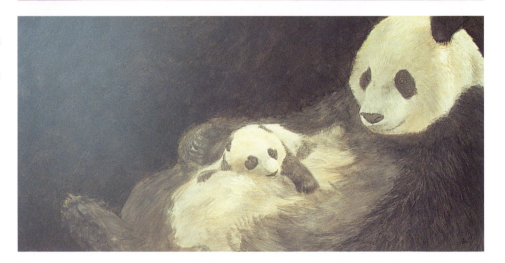

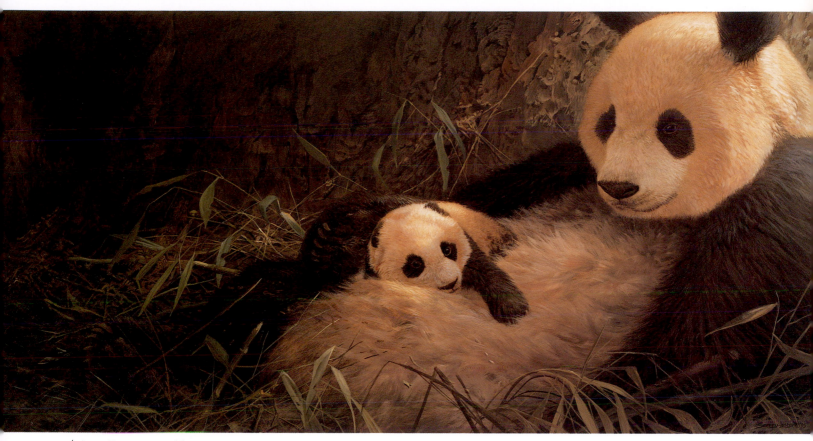

6 | ADD FINISHING TOUCHES

Paint the background with a ⅜-inch (10mm) flat brush and Payne's Gray, Burnt Sienna and Burnt Umber. Emphasize certain areas with a dark mixture of Payne's Gray, Burnt Umber and Ultramarine Blue. Add two more washes of Burnt Sienna to the entire painting with a 2-inch (51mm) house-painting brush. Although you've done the rest of the painting in acrylic, use oil paint to add highlights. Highlight the light fur on each of the pandas' heads and on the patch of bamboo to the left of the baby with a mixture of Naples Yellow, Titanium White and Cadmium Yellow.

MO TSI
24" × 48" (61cm × 122cm) | Mixed media on panel | 1995

Studying Feathers

Make sure you're familiar with each bird's structure and characteristics before painting it. Understanding a bird makes rendering it accurately easy. Every bird perches differently and has specific characteristics. Study reference books to become familiar with a bird before you paint it. Here are a few resources: *The Sibley's Guide to Birds*, Roger Tory Peterson Bird Guides and The Audubon Series.

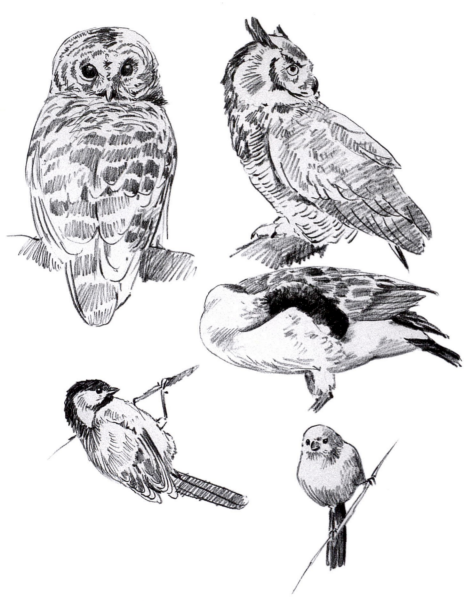

DIFFERENT BIRDS REQUIRE DIFFERENT APPROACHES

The blue jay (top) shows very fine brushwork and individual feathers. I painted it with a ⅜-inch (10mm) flat brush and a liner. The scarlet macaw (above) shows a much more direct approach. I established the dark areas between the feathers first, then blocked in some actual feathers. I again added the feather detail with a liner.

UNDERSTAND CHARACTERISTICS

These field studies help me paint accurate, believable final paintings. The two owls at the top exhibit a common owl pose, swivelling their heads all the way around to look backwards. The bird preening (middle) provides an interesting pose to paint. The songbirds at the bottom perch on branches much differently from the birds above them.

Painting Feathers

Feathers, like fur, are much easier to paint after studying the particular bird you want to paint and determining the right brushstrokes to use.

BLEND FEATHERS

I laid down a wash of Burnt Sienna and white gesso over the whole panel. I painted the eyes and bill first. Then I painted in the feathers with pure gesso and laid a thin wash of Burnt Sienna and Cadmium Yellow over the whole painting. I painted the highlight areas on top of the head and shoulder last. Notice how the cockatoo blends into the background in a few places.

MOLUCAAN COCKATOO
12" × 9" (30cm × 23cm) | Acrylic on Masonite | 1995

USE DIFFERENT STROKES

I always strive for interesting compositions in my work. Besides having unique composition, this painting shows a range of feathers from the tiny feathers on the adult's head and neck to the large feathers on its back and shoulder. I painted the adult's feathers prominently and boldly. The hatchlings' feathers are smaller and finer. Each kind of feather in this painting requires a different approach to brushwork.

THE HATCHLINGS—OSTRICH
36" × 18" (91cm × 46cm) | Oil on Masonite | 1992

FIND DIFFERENT LIGHT
The fascinating lighting under these egrets' wing linings and axillars and the white plumage silhouetted against the dark background inspired me to do this painting.

THE COURTSHIP
18" × 36" (46cm × 91cm) | Acrylic on Masonite | 1994

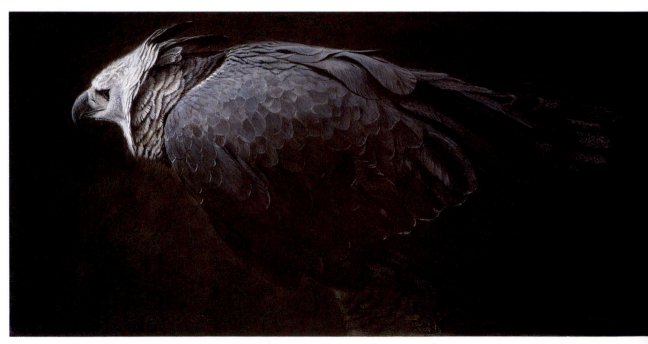

FEATHERS CHANGE
The harpy eagle has very monochromatic plumage, which makes it an interesting and challenging subject to paint. The neck and head crest of the bird are fascinating and examples of the different kinds of feathering each bird has. I let the back of the bird fade into the simple dark background to focus on the head.

FREEDOM I
18" × 36" (46cm × 91cm) | Acrylic on Masonite | 1993

Painting Feathers in Acrylic

MATERIALS LIST

BRUSHES
Pro Arte series 106 ⅜-inch
(10mm) flat

COLOR PALETTE
Winsor & Newton Finity acrylics
Burnt Umber ~ Payne's Gray

SURFACE
Masonite

Feathers can differ not only from bird to bird, but also from one part of the bird to another. Notice the different brushstrokes you'll use to paint the smaller feathers near the shoulder.

1 | BLOCK IN FEATHERS
Block in the shapes of the feathers with a light wash of Payne's Gray. For the small feathers on the left near the shoulder, make a diamond shape with the corner of the flat brush.

2 | DEFINE FEATHERS
Repeat step 1, this time laying in a heavier wash and defining the feathers a little more. Start your brushstrokes dark at the top and let them fade out toward the tips.

3 | ADD MORE DEFINITION
Lay a wash of Burnt Umber and Payne's Gray over the feathers. Paint in the light tips of the feathers to make them stand out.

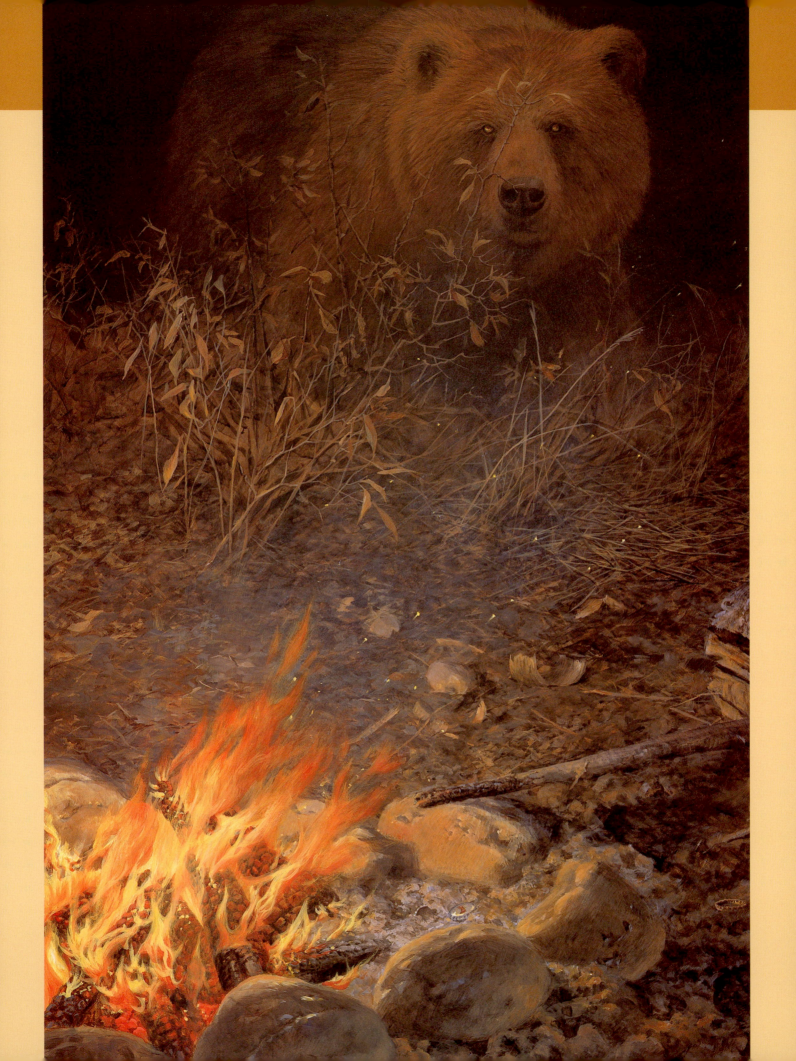

Painting Habitat

In wildlife painting, habitat is as important as the main subject. Understand the size and scale of elements within a habitat, and accurately depict your subject in comparison. Devise a way of measuring elements when doing field research so you can remember the scale when you return to the studio to paint. I often place my lens cap next to an element in a scene for scale before taking a photograph. On sketches I simply make notes for future reference. You never know when you'll need that information.

In this chapter we'll look at ways to make elements an important part of a composition. You'll paint trees, ground cover, grass, water, skies and snow. These elements all vary tremendously. Each kind of tree has different bark and branch formation. Ground cover is anything that falls under my definition of "stuff," from dead leaves to low-lying tundra. Grass also varies considerably, but as with ground cover, the key is to paint it so it doesn't look contrived. When focusing on a subject in the field, your eyes automatically simplify the rest of the scene for you. If you paint the same way, the results will look more natural and realistic.

ADD TO SCENE
I included several elements in this painting: fire, ashes, beer bottle caps, rocks, tree bark, footprints, willows, dead grass, smoke and sparks. All are in addition to the subject, the grizzly. The fire is the focal point, making the bear a secondary point of interest. Still, the flames lead the viewer's eye through the piece to the bear.

MAKING TRACKS
40" × 30" (102cm × 76cm) | Acrylic on Masonite | 1998

Painting Lion's Habitat in Acrylic

To paint successfully, you need a good composition. The elements in your subject's habitat can help you pull this off. Something as simple as the direction of trodden grass or as obvious as deadfall or tracks in the snow all work to aid the composition. When researching in the field, sketch or photograph the elements you feel will help a future painting. This demonstration studies the placement of rocks, partially hidden by grass, that take the viewer's eye to the lion. The small bush behind the lion is another important element in the painting's design.

1 | BEGIN BLOCKING IN

Prime the canvas with a mid-gray mixture of Burnt Umber, Payne's Gray, Ultramarine Blue and gesso. Block in the lion with a ⅜-inch (10mm) flat brush. Block in the shadows with a ¾-inch (19mm) flat brush and thin washes of a mixture of Burnt Sienna, Yellow Ochre and Burnt Umber. Block in some of the habitat with a mixture of Payne's Gray and Raw Sienna. Leave spaces on the ground for the rocks, which you'll paint later to create a path to the lion for the viewer's eye. Paint the background behind the lion with Ultramarine Blue, Flesh Tint and gesso.

2 | FINISH BLOCKING IN

Block in the rest of the background and foreground with a ¾-inch (19mm) flat brush. Paint over the background with a mixture of Cadmium Red, Ultramarine Blue, Payne's Gray and gesso. Highlight the tops of the rocks with thin washes of gesso. Add more ground cover with a 1¼-inch (31mm) flat and a mixture of Raw Sienna and Payne's Gray. Highlight the leaves on the bush with a mixture of Yellow Ochre, gesso and a touch of Ultramarine Blue.

3 | ADD DETAIL

Add more light to the lion, bush and rocks to define their shapes. Paint the grass with the edge of a 1¼-inch (31mm) flat brush and a mixture of Yellow Ochre and gesso. Define the dark areas of the bush and grass with a ¾-inch (19mm) flat brush and a mixture of Payne's Gray, Ultramarine Blue and Burnt Umber.

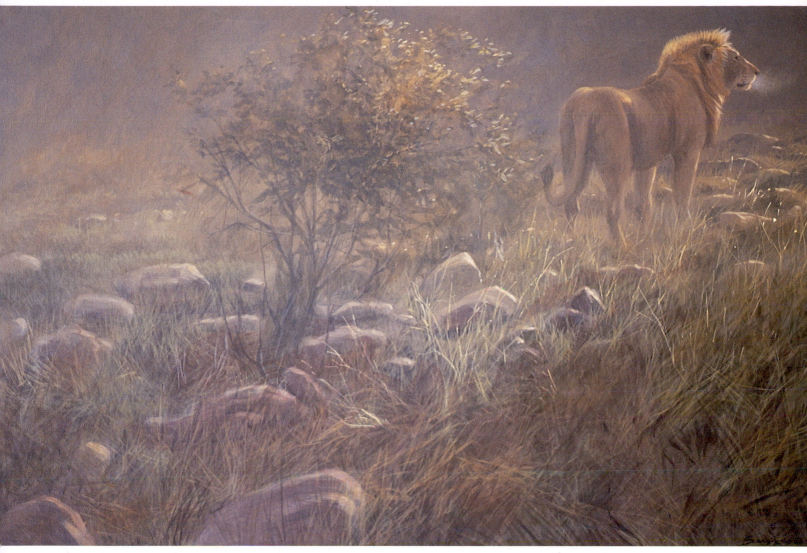

4 | ADD FINISHING TOUCHES

Drybrush the lion's breath with gesso and Naples Yellow. Add highlights to the tips of the grass and the sides of rocks closest to the lion with a ⅜-inch (10mm) flat brush and a mixture of Cadmium Yellow, Naples Yellow and gesso. Lay a light wash of a mixture of Payne's Gray and Burnt Sienna over the lower left quarter of the painting. Allow this to dry, then lay in a wash of Yellow Ochre over the whole painting with a 2-inch (51mm) house-painting brush. Follow this with a wash of Burnt Sienna over the whole painting.

MARA MORNING
24" × 36" (61cm × 91cm) | Acrylic on canvas | 2001

Painting Tree Bark in Acrylic

Although tree bark is a small detail in most wildlife paintings, painting it correctly will add to the authenticity of any painting.

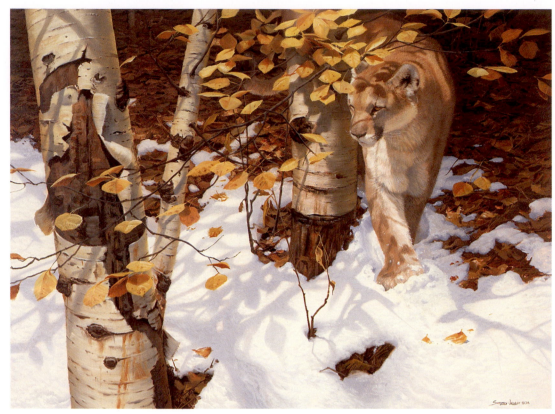

ADD INTEREST WITH ELEMENTS
This painting shows how you can incorporate the paper birch bark in this demonstration into a major painting.

AUTUMN COUGAR
30" × 40" (76cm × 102cm) | Oil on canvas | 1996

1 | ESTABLISH SHAPES
Prime a Masonite panel with a mid-gray mixture of Ultramarine Blue, Payne's Gray and Burnt Umber and white gesso. Paint in the tree shapes with pure gesso and a ¾-inch (19mm) flat brush.

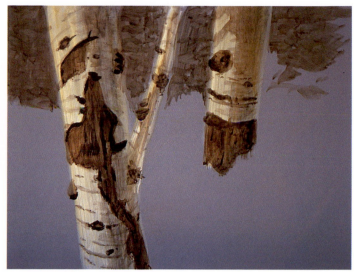

2 | BLOCK IN BARK

Block in the broken and dark areas of the tree exposed by the missing bark with a ¾-inch (19mm) flat brush and a mixture of Burnt Umber and Ultramarine Blue. Add shadows to the trees with a mixture of Payne's Gray and Naples Yellow. Darken the background with a mixture of Burnt Sienna and Payne's Gray to provide some contrast.

3 | BUILD UP DARKS

Add the cracks and notches in the bark and strengthen the darks of the exposed wood with a ⅜-inch (10mm) flat brush and a mixture of Burnt Umber and Burnt Sienna. Keep in mind the light source coming in from the left. Paint the short darks—the dark, negative space between elements, such as bark and grass—with a mixture of Burnt Umber, Ultramarine Blue and Payne's Gray. Emphasize the shadows on the bark with a ½-inch (12mm) flat brush and a mixture of Naples Yellow, Flesh Tint and Payne's Gray.

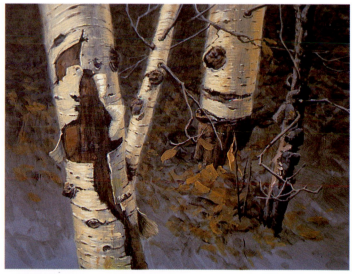

4 | ADD MORE DETAIL

Emphasize the highlights on the tree trunks with a ⅜-inch (10mm) flat brush and a mixture of Naples Yellow and gesso. Paint in the reflected light on the right sides of the trees with a mixture of Yellow Ochre and Naples Yellow. Highlight the exposed wood of the trees with a mixture of Burnt Sienna, Burnt Umber and gesso. To balance the scene, add a sapling to the right of the other trees with a mixture of Burnt Umber, Payne's Gray and Ultramarine Blue. Add to and extend the ground cover with a 1¼-inch (31mm) flat brush and Yellow Ochre, Cadmium Yellow and Cadmium Red.

5 | ADD FINISHING TOUCHES

Soften the shadows with a ½-inch (12mm) flat brush and a wash of gesso, Flesh Tint and Naples Yellow. Emphasize the short darks with a ⅜-inch (10mm) flat brush and a dark mixture of Ultramarine Blue, Payne's Gray and Burnt Umber. Paint the green leaves with a mixture of Ultramarine Blue and Yellow Ochre. Paint a dead leaf with Yellow Ochre and Burnt Sienna to add interest. Apply a mixture of Naples Yellow and gesso to the highlighted areas. Add the branches with a liner brush and a mixture of gesso, Burnt Umber and Payne's Gray.

Painting Ground Cover in Acrylic

MATERIALS LIST

BRUSHES
Pro Arte series 103 liner
Pro Arte series 106 flats
 ⅜-inch (10mm) ~ ¾-inch
 (19mm) ~ 1¼-inch (31mm)
2-inch (51mm) house-painting
 brush

COLOR PALETTE
Winsor & Newton Finity acrylics
 Burnt Sienna ~ Burnt Umber
 ~ Cadmium Yellow ~ Naples
 Yellow ~ Payne's Gray ~
 Raw Sienna ~ Ultramarine
 Blue ~ Yellow Ochre

OTHER
white gesso

SURFACE
24" × 20" (61cm × 51cm)
 Masonite

The ground cover serves a necessary purpose in this painting, drawing the viewer's eye to the gorilla.

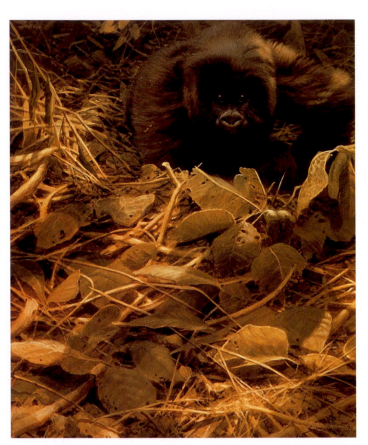

ADD TO COMPOSITION
This demonstration focuses on ground cover. Ground cover plays a prominent, important part of the design in this painting.

YOUNG MOUNTAIN MAN
24" × 20" (61cm × 51cm) | Acrylic on Masonite | 1994

1 | LAY DOWN BASIC STROKES
This painting will be a fun release from your normal painting routine because anything goes when painting ground cover. Prime a Masonite panel with a mid-gray mixture of Burnt Umber, Payne's Gray, Ultramarine Blue and gesso. Apply the leaves and twigs with a ¾-inch (19mm) flat brush and Naples Yellow, Raw Sienna and Yellow Ochre, using haphazard, random brushstrokes. A loose painting technique will make the piece more realistic. Paint in the dark areas between the leaves and twigs with a mixture of Burnt Umber and Payne's Gray.

2 | DEFINE SHAPES

Lay a wash of Burnt Umber and then a wash of Payne's Gray over the painting with a 1¼-inch (31mm) flat brush. Allow the painting to dry after each wash. Define the shapes of the leaves and twigs with a ¾-inch (19mm) flat brush and a mixture of Cadmium Yellow, Naples Yellow and Yellow Ochre. Emphasize the dark areas between the leaves and twigs with a ¾-inch (19mm) flat brush and a dark mixture of Burnt Umber, Ultramarine Blue and Payne's Gray.

3 | PAINT MORE DEFINED LEAVES

Paint in more leaves and twigs with a ⅜-inch (10mm) flat brush and Naples Yellow and Yellow Ochre. Allow this to dry. Add more leaves with a ⅜-inch (10mm) flat brush and a mixture of Cadmium Yellow, Ultramarine Blue and Yellow Ochre. When dry, lay a wash of Burnt Sienna over the whole painting.

4 | ADD DEPTH

When painting ground cover, think in terms of layers. Put shadows under the twigs, stalks and leaves you've painted so far with a ⅜-inch (10mm) flat brush and a mixture of Burnt Sienna and Payne's Gray. When this is dry, lay a wash of Payne's Gray over the whole painting with a 1¼-inch (31mm) flat brush. When the wash dries, add more leaves, this time more opaque, with a ⅜-inch (10mm) flat brush and a mixture of gesso, Cadmium Yellow, Yellow Ochre and a touch of Ultramarine Blue.

5 | PULL IT TOGETHER

Put in more detail on the leaves, twigs and stalks by emphasizing the highlights with a ⅜-inch (10mm) flat brush and a mixture of Yellow Ochre and gesso. Then put in new leaves and stalks with the same mixture to add variety and help the design. Use a liner brush for the very small stalks. When everything is dry, lay in a wash of Burnt Sienna to pull the painting together.

Painting Grass in Acrylic

MATERIALS LIST

BRUSHES
Pro Arte series 103 liner
Pro Arte series 106 flats
⅜-inch (10mm) ~ 1¼-inch
(31mm)

COLOR PALETTE
Winsor & Newton Finity acrylics
*Burnt Sienna ~ Burnt Umber
~ Cadmium Yellow ~ Payne's
Gray ~ Raw Sienna ~ Ultra-
marine Blue ~ Yellow Ochre*

OTHER
white gesso

SURFACE
20" × 30" (51cm × 76cm)
Masonite

Just like when painting ground cover, keep your brushstrokes loose when painting grass. Paint the form of the grass as a whole rather than individual blades. Then paint layers of grass just as you painted fur, layering washes of color and gesso to achieve depth.

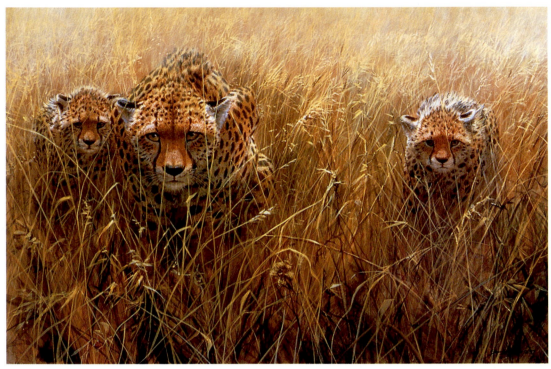

WORK TOGETHER
The grass is a dominant element in this painting of a cheetah family on the hunt.

KIDOGO HUNT
20" × 30" (51cm × 76cm) | Acrylic on Masonite | 1997

1 | INDICATE FORM

Prime a Masonite panel with a mid-gray mixture of Ultramarine Blue, Burnt Umber, Payne's Gray and white gesso. Block in the basic form of the grass with the edge of a 1¼-inch (31mm) flat brush and a light wash of a mixture of Burnt Umber and Burnt Sienna.

2 | LAYER GRASS

Lay in a wash of a mixture of Raw Sienna and Yellow Ochre with a 1¼-inch (31mm) flat brush. Once this is dry, paint in more grass with the mixture from step 1. Paint some darker blades with a mixture of Payne's Gray and Raw Sienna. Then paint the lighter blades of grass with the edge of a ⅜-inch (10mm) flat brush with a mixture of Yellow Ochre and gesso.

3 | ADD DEPTH

When the brushwork from step 2 is dry, lay a wash of a mixture of Burnt Sienna and Raw Sienna over the whole painting with a 1¼-inch (31mm) flat.

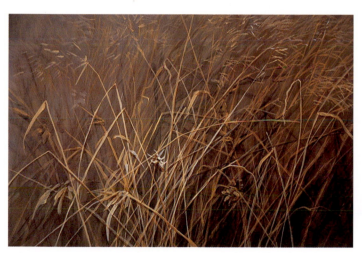

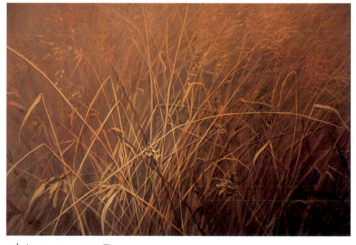

4 | ADD ANOTHER LAYER

Add as many layers of grass as you need. Paint in the shadows under and between the grasses with a ⅜-inch (10mm) flat brush and a mixture of Burnt Umber and Payne's Gray. Paint the light grasses with a mixture of Yellow Ochre and gesso. Add a wash of Burnt Umber at the bottom of the painting to add depth.

5 | ACCENTUATE DEPTH

Lay a wash of a mixture of gesso and Yellow Ochre over the top third of the painting with a 1¼-inch (31mm) flat brush. When this is dry, apply a wash of Cadmium Yellow and Raw Sienna over the whole painting. Then add more grass and emphasize the light and dark grasses with a ⅜-inch (10mm) flat brush. Then lay a wash of Burnt Sienna over the whole painting.

Painting Water in Acrylic

Paint the ripples in the water in this demonstration with a crosshatching technique. Perspective applies on sea as well as land, so keep it in mind as you paint the ripples, especially those in the moonlight reflections.

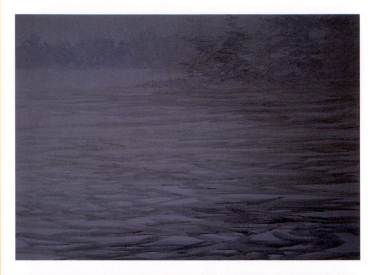

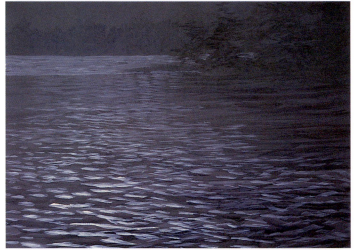

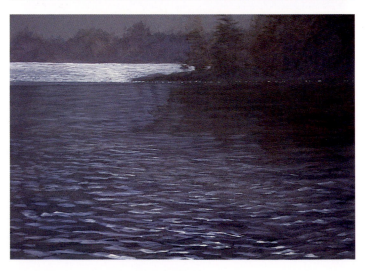

1 | BLOCK IN BASIC SHAPES
Prime the panel with a mid-gray mixture of Payne's Gray, Burnt Umber, Ultramarine Blue and white gesso. Lay in the water with a thin wash of Payne's Gray. Create the ripples by crosshatching with the thin edge of a 1¼-inch (31mm) flat. Then indicate the background tress and the middle ground.

2 | ADD HIGHLIGHTS
Highlight the ripples in the water with a 1¼-inch (31mm) flat brush and thin, pure gesso. Keep perspective in mind as you paint the ripples; they become less distinct as they recede into the distance. Add extra highlights to the windblown stretch of water beyond the middle ground with a ⅜-inch (10mm) flat brush.

3 | LAY IN COLORS
Paint the reflections of the middle-ground trees with a mixture of Ultramarine Blue and Raw Sienna. Lay a wash of a mixture of Payne's Gray and Ultramarine Blue over all of the water. Then lay a wash of a mixture of Burnt Sienna and Raw Sienna over the middle-ground trees and their reflections. Paint over the background and middle-ground trees with a mixture of Cadmium Red, Flesh Tint and Ultramarine Blue. Add a wash of Payne's Gray over the water. Then emphasize the highlights in the water, particularly in the background, with gesso.

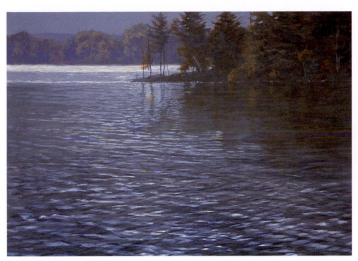

4 | DEFINE DETAILS

Define the ripples in the water with a ⅜-inch (10mm) flat brush and a mixture of gesso and a touch of Payne's Gray. With the same brush, add details to the middle-ground trees with Burnt Sienna, Raw Sienna, Naples Yellow, Payne's Gray and Flesh Tint. Paint the reflections with the same colors. Soften the horizon with a thin wash of Payne's Gray and gesso. Then paint over the sky with a mixture of Burnt Umber, Ultramarine Blue, Payne's Gray, Cobalt Blue and gesso. Add detail to the background trees with a mixture of Ultramarine Blue, Cadmium Red and Flesh Tint.

5 | DEFINE RIPPLES

When the water dries, use a crosshatching technique to apply as much or as little as you want of a mixture of Payne's Gray and gesso. Then cover the area with a wash of Raw Sienna and Payne's Gray with a 1¼-inch (31mm) flat brush.

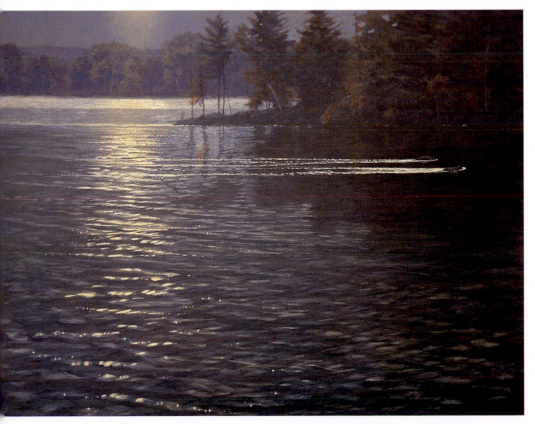

6 | ADD FINISHING TOUCHES

Now comes the fun part and the last obstacle to a successful painting. Following the perspective you established for the ripples in step 1, paint the moonlight reflections with the corner of a ⅜-inch (10mm) flat brush. Paint the loons with simple strokes of Payne's Gray. Extend and emphasize their wake with a mixture of Naples Yellow, Cadmium Yellow and gesso. Put in what I like to call the "Disney sparkles" in the water with a liner brush and a mixture of gesso and Cadmium Yellow. Then drybrush haze for the shaft of moonlight leading down to the water.

MOONLIGHT SERENADE
16" × 20" (41cm × 51cm) | Acrylic on Masonite | 2001

Painting Clouds in Oil

MATERIALS LIST

BRUSHES
Langnickel Royal sable series
 5590 flats
 no. 4 ~ no. 16 ~ no. 33 ~
 no. 44
2-inch (51mm) house-painting
brush

COLOR PALETTE
Rembrandt Artist Quality oils
 Cadmium Red ~ Cadmium
 Yellow ~ Flesh Tint ~
 Naples Yellow ~ Payne's
 Gray ~ Titanium White ~
 Transparent Red Oxide ~
 Ultramarine Blue

OTHER
paper towel
turpentine
white gesso

SURFACE
11" × 14" (28cm × 36cm) canvas

Clouds are unique elements to paint because there is so much distance between them and the viewer in real life. Because the sun is low in the sky in this painting, the shadows appear on the tops of the clouds. Remember to keep the edges of the clouds soft. The elephants at the bottom add scale to show the viewer just how magnificent this cloud formation is.

1 | BLOCK IN CLOUDS

Prime the canvas with thick gesso and a 2-inch (51mm) house-painting brush, allowing the brushstrokes to show. Let this dry fully. Then glaze the canvas with a no. 33 flat brush and a mixture of Cadmium Red, Flesh Tint, Cadmium Yellow and turpentine. Rub off the excess paint with a paper towel before it dries. Block in the highlight areas of this cumulonimbus cloud with a no. 16 flat brush and a mixture of Cadmium Yellow, Flesh Tint and Titanium White.

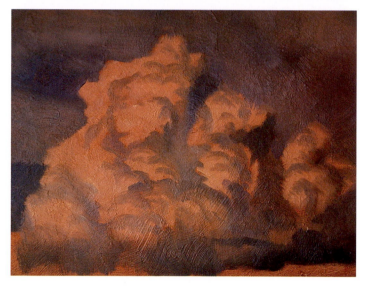

2 | ESTABLISH CONTRAST

The sun is about to set behind the viewer, so the sky is starting to get dark. Paint in the sky with a no. 44 flat brush and Ultramarine Blue and Flesh Tint. While the paint is still wet, block in shadows on and between the clouds with a no. 16 flat brush and a mixture of Ultramarine Blue, Payne's Gray and Flesh Tint. The shadows will be on top of the clouds because the sun is low in the sky behind you. It's OK if some of the underpainting still shows through.

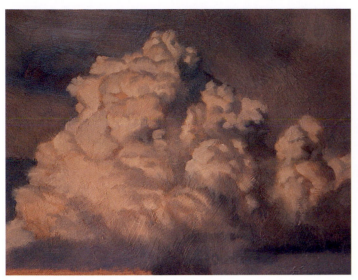

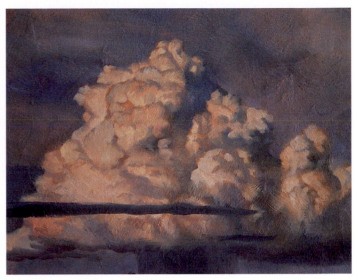

3 | SOFTEN EDGES

Emphasize the existing highlights and add new ones with a no. 4 flat brush and a mixture of Cadmium Yellow, Flesh Tint and Titanium White. Blend the edges by pulling the light areas into the dark areas. Drag the shadow area to the horizon with a no. 4 flat and a mixture of Payne's Gray and Flesh Tint.

4 | ADD ACCENTS

Add more highlights to the cloud with Titanium White. Lighten the sky with Titanium White and Flesh Tint. In the foreground, paint a couple of stratocumulus clouds that aren't catching the light of the sun with a no. 16 flat brush and a mixture of Flesh Tint, Cadmium Red and Payne's Gray. Use the same mixture to paint the distant rainstorm below the clouds. Paint the horizon with a no. 16 flat brush and a mixture of Transparent Red Oxide, Payne's Gray and Ultramarine Blue.

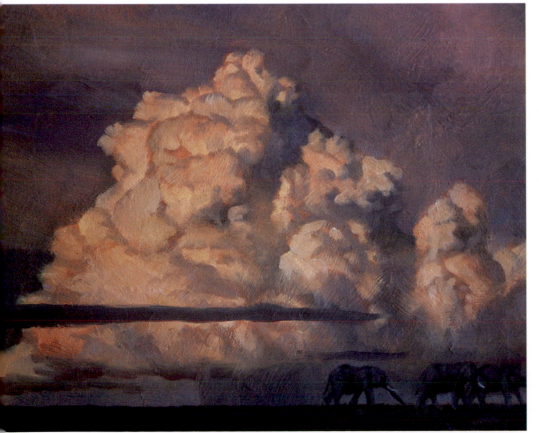

5 | ADD FINISHING TOUCHES

Add more light to the cloud with Titanium White, Naples Yellow and Flesh Tint. Raise the horizon slightly to give the elephants something to stand on. Paint them with a no. 4 flat brush and a mixture of Payne's Gray, Transparent Red Oxide, Titanium White and Flesh Tint. Paint the tusks with Titanium White and add some subtle shadows underneath the elephants with Payne's Gray. In addition to creating more interest, the elephants provide a scale for the viewer to see how massive the cloud really is.

A WALK IN THE CLOUDS
11" × 14" (28cm × 36cm) | Oil on canvas | 2001

Painting Snow in Oil

MATERIALS LIST

BRUSHES
Langnickel Royal sable series
5590 flats
 no. 4 ~ no. 16 ~ no. 30

COLOR PALETTE
Rembrandt Artist Quality oils
 Cadmium Yellow ~ Cobalt
 Blue ~ Flesh Tint ~ Naples
 Yellow ~ Payne's Gray ~
 Titanium White ~ Ultrama-
 rine Blue
Winsor & Newton Finity acrylics
 Burnt Umber ~ Payne's Gray
 ~ Ultramarine Blue

OTHER
white gesso

SURFACE
12" × 16" (30cm × 41cm) canvas

Painting snow is a demanding task because it comes in so many forms. For instance, soft, freshly fallen snow has a much different appearance from the powdery snow found in drier climates; frozen, hard snow usually has thawed partially and then frozen again; and ground cover sometimes shows through melting snow. I like to paint snow in advection fog—fog formed from the interaction between snow on the ground and moisture in the air. Wind can blow snow around to create a ground blizzard or sculpt it to create interesting forms. The most important task when painting snow is to select appropriate lighting. Remember that snow, in all forms, is very reflective. Painting accurate perspective with this lighting also helps indicate depth of snow.

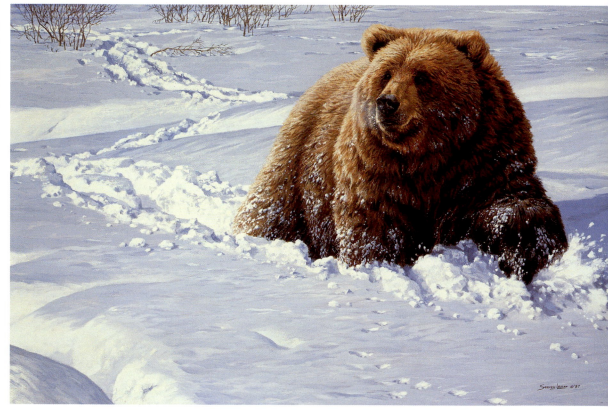

CRUISE ALONG

You'll paint this bear's tracks through the snow. The light source in this painting, the sun, is set low in the sky, so the undisturbed snow has a darker value than the tracks and vertical slopes, which catch more light. For a touch of authenticity, I added the branch, which is trodden down and broken after getting in the bear's way.

HEAVY GOING—GRIZZLY
24" × 36" (61cm × 91cm) | Oil on canvas | 1987

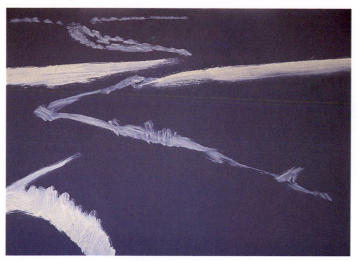

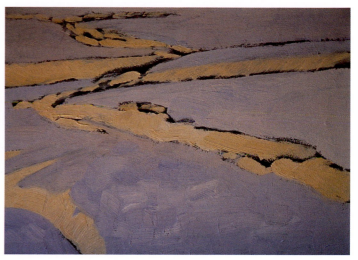

1 | ESTABLISH COMPOSITION

Prime a canvas with a mid-gray mixture of Ultramarine Blue, Burnt Umber and Payne's Gray acrylics and white gesso. Indicate the highlight areas with a no. 30 flat brush and a mixture of Titanium White and Naples Yellow.

2 | UNDERPAINT SNOW

Underpaint the surface of the snow with a no. 30 flat brush and a mixture of Ultramarine Blue, Flesh Tint and Titanium White. Paint a warm base for the highlighted areas with the same brush and a mixture of Naples Yellow and Flesh Tint, keeping the paint thick. Leave gaps between the surface color and the highlight color.

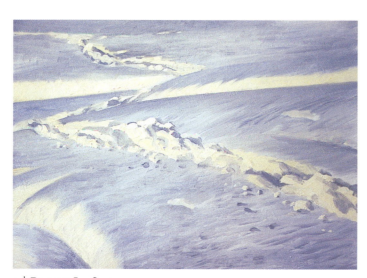

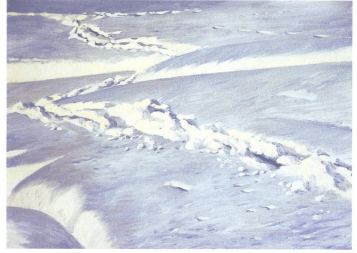

3 | BLOCK IN SNOW

Block in the tracks and highlights with a no. 16 flat brush and a thick mixture of Titanium White and Naples Yellow, covering the gaps you left in step 2. Block in the surface of the snow with a mixture of Payne's Gray, Titanium White, Ultramarine Blue and Flesh Tint.

4 | ADD FINISHING TOUCHES

Reemphasize the highlights with a no. 4 flat brush and a mixture of Cadmium Yellow and Titanium White. Create more definition in the tracks by adding shadow areas with a mixture of Cobalt Blue, Payne's Gray and Titanium White. Define the surface of the snow by applying a mixture of Naples Yellow, Flesh Tint, Titanium White and Ultramarine Blue for surface indentations, particles of snow and cast shadows.

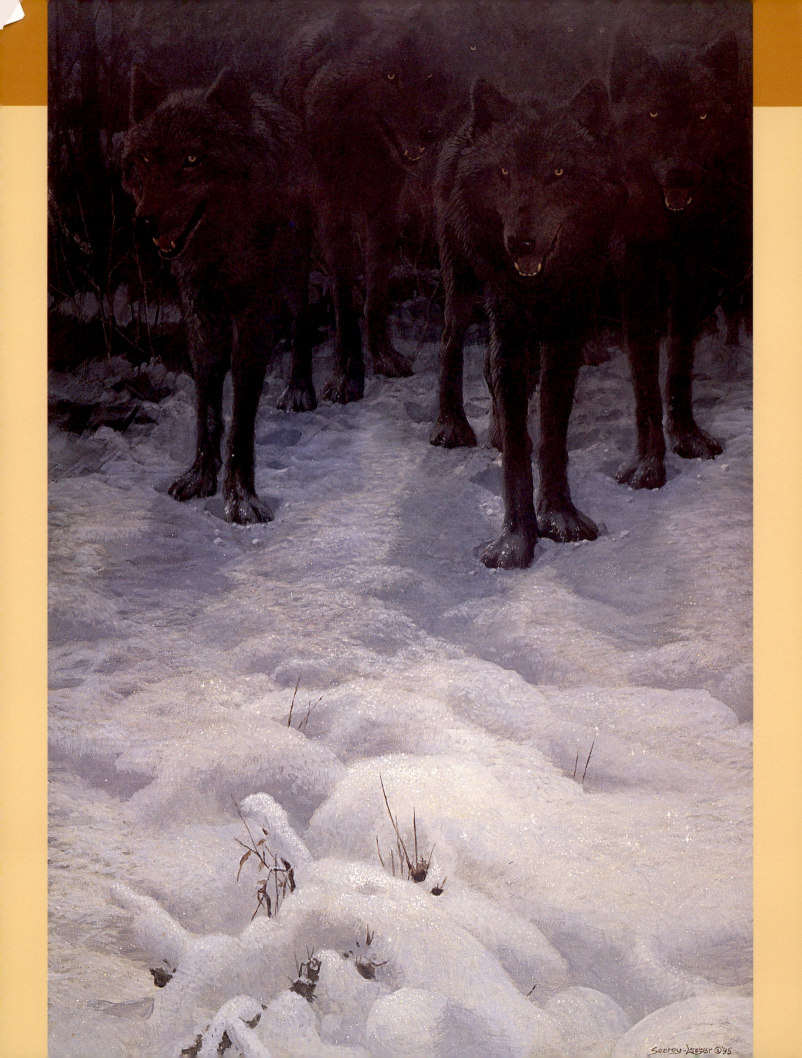

Painting Atmosphere

As with light and composition, your choice of atmosphere affects the success of your painting. Use atmosphere to establish the mood you desire. Use moonlight, a rising sun or a sunset for subtle lighting. Play with weather conditions. In this chapter we'll examine elements from nature and the possibilities they offer for painting atmosphere. For example, you can paint mist with dry-brush strokes, washes or glazes to add another dimension and set the mood. Rain changes the entire feel of a painting. I often use misty rain, drizzle or heavy rain as a setting for a painting. Snow sets an entirely different tone from rain and mist. Not only does snow provide white space, but it also provides substance and an aura all its own. Falling snow can consume the entire environment, offering the viewer a soothing sensation.

USE DARK, MYSTERIOUS ATMOSPHERE
Nothing can create an atmosphere quite like black timber wolves staring out of an equally dark setting. I applied a series of progressively darker washes over the wolves to blend them into the background.

NIGHT OF A THOUSAND EYES
36" × 24" (91cm × 61cm) | Acrylic on Masonite | 1995

Painting a Panda in Mist

Pay attention to the changes in the pandas and the paintings' overall tones as I paint them in different atmospheres: mist, rain and snow. Pandas are often shrouded in mist in their natural habitats. I like to use this element to provide a mysterious mood for a painting.

BLOCK IN
After priming Masonite, I blocked in the darks on the panda and the tree first, then the lighter fur. Next I painted the shadow areas on the panda's fur. After establishing the lights and darks on the subject, I blocked in the background.

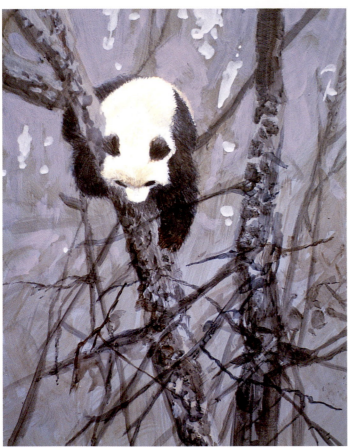

ADD DETAILS
I emphasized the lights and darks, then added another tree to the foreground to balance the scene. I repainted the background with an opaque mixture and added details to the tree bark and the panda's fur. Finally I indicated spots of light that will shine through the mist and trees.

PAINT MIST
I added light tones and midtones to the trees and let the paint dry. Then I applied a wash of gesso, followed by a thin wash of Yellow Ochre, over the entire painting. I darkened the tree in the foreground and added branches and foliage. To finish the mist, I applied another wash of gesso, then a wash of Payne's Gray and gesso.

Painting a Panda in Rain

Pandas in western China live in a mountainous environment with much rainfall. I enjoy incorporating this element into my paintings.

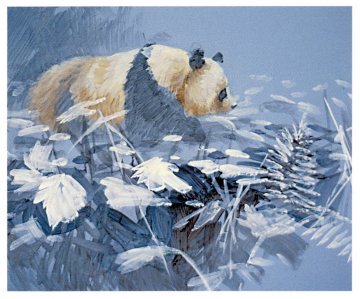

BLOCK IN

I blocked in the lights and darks on the panda and the darks in the background. Then I painted in the shapes of the leaves with pure gesso. As I painted, I indicated the directions of the fur and the veins on the leaves. I also added some dark areas between the leaves.

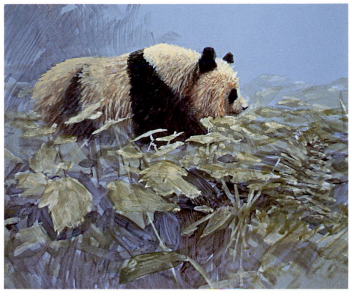

ADD COLOR

I emphasized the panda's lights and darks and added more detail to the fur, remembering that the panda's fur will be wet and clumpy. I used Raw Sienna, Burnt Sienna and gesso to paint the light fur because rain also will make the panda's fur look a bit dirtier. I refined the shapes of the leaves and washed a mixture of Cadmium Yellow, Ultramarine Blue and Yellow Ochre over the foliage.

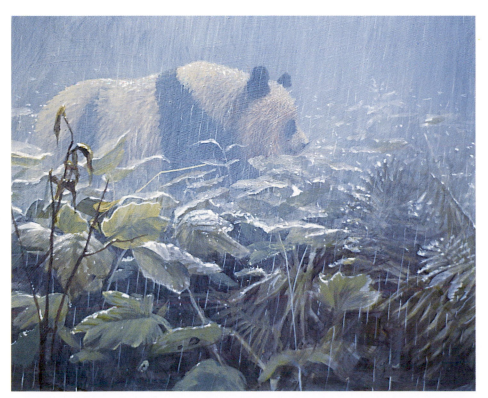

FINISH UP

I added highlights to the leaves and painted the rain with a liner brush and gesso. Mist is the overriding element in a misty atmosphere, but a rainy atmosphere requires many more elements to get the full effect. I added more color to the leaves to redefine them and add more foliage. I washed gesso over the background and panda only. I followed that with washes of gesso and a mixture of Payne's Gray and gesso with downward brushstrokes in the direction of the rain. I added more darks, highlights and color to the foliage in the foreground and laid down another wash of a mixture of Payne's Gray and gesso.

Painting a Panda in Snow

Snow is one of my favorite elements to paint. It provides so many possibilities for composition, interest and the beauty of white space.

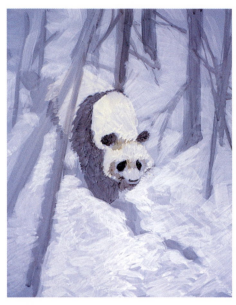

BUILD UP SNOW
The mid-gray base color is very important to achieving depth when painting snow. I laid in the darks of the trees and the panda and then the light fur. Then I laid in the snow with the edge of a flat brush and thin, pure gesso. I built form into the snow with short, dashlike brushstrokes and a crosshatching technique. Rather than adding shadows later, I merely allowed the base color to show through at this point.

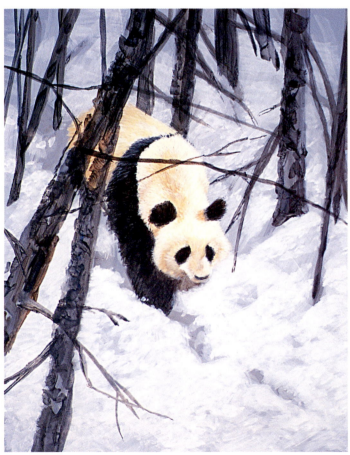

EMPHASIZE DARKS AND LIGHTS
I emphasized the darks and lights, added detail to the trees and the panda and applied more gesso with a crosshatching technique for the snow.

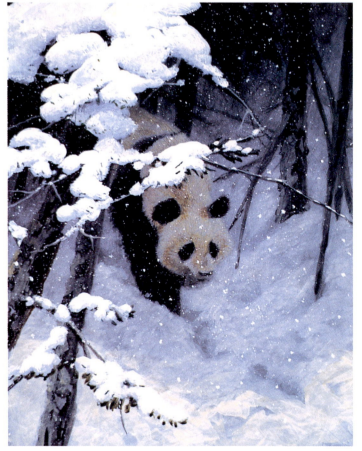

PULL IT TOGETHER
I painted shadows over the panda and snow and painted foliage on the trees. When that dried, I painted snow lying on the foliage and added shadows to the snow. To clinch the atmosphere's effect, I splashed on snowflakes with a toothbrush.

Changing Atmosphere

You can stick to your original design concept and still change the atmosphere of any painting if it isn't working for you. If you're having trouble with a painting, put it aside and come back to it days, weeks, months or even years later. You may come up with a different idea for a setting or atmosphere when you pick it up again.

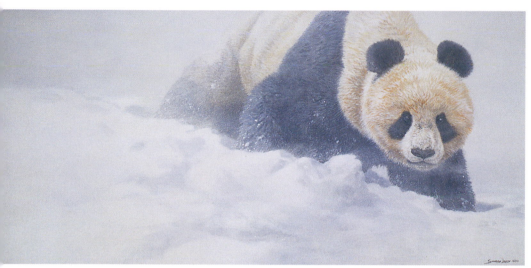

IF YOU DON'T LIKE IT, CHANGE IT
I changed the setting, and thus the atmosphere, between these very similar paintings. I painted the panda in a blizzard, but I wasn't happy with it, so I put it in a more tropical setting.

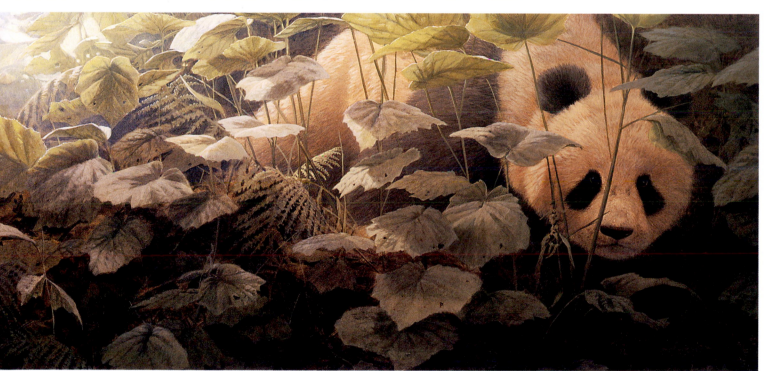

CHANGE SETTING
I painted the blizzard piece (at top) in 1993. Almost six years later, I designed a new concept that changed the mood entirely. I brought in foliage over the snow and changed the light source. I often keep paintings in the garage for several years if I'm not completely happy with the result, hoping I'll find a way to make them work later.

CHINA DAWN
24" × 36" (61cm × 91cm) | Acrylic on Masonite | 1998

EXPERIMENT

Experiment with atmospheric ideas before starting the final painting. This study of a grizzly on the tundra shows a storm approaching in the background. The cloud formation adds drama to an otherwise tranquil piece.

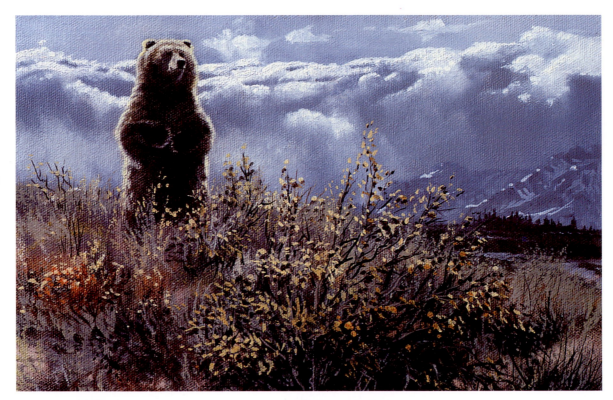

STUDY ALTERNATIVE

Using a similar composition, I changed the setting, adding mist to the background and a light snow. Paintings based on each of these studies would yield very different feelings. Even if I choose neither of them as the basis for a final painting, the exercise has been worthwhile as part of the learning process of what does and does not work.

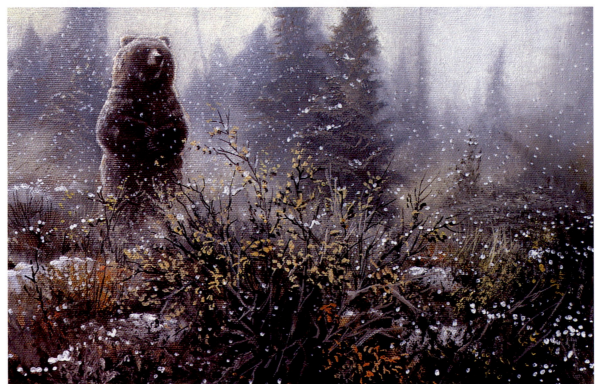

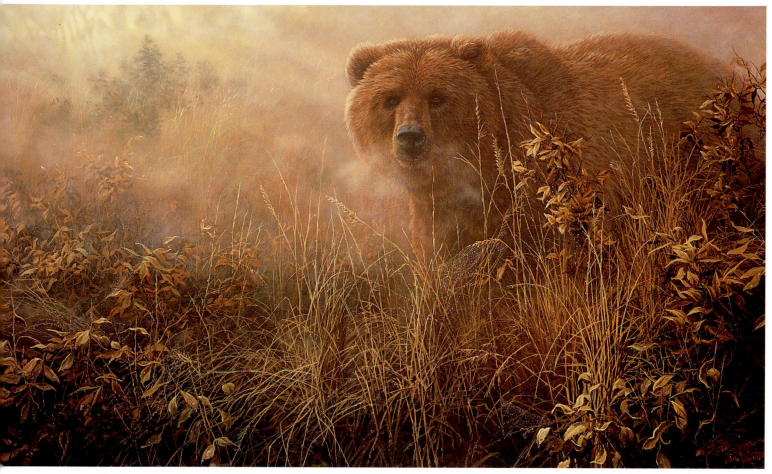

CREATE UNIQUE FEELING
The early morning mist sets the tone of this piece. The grizzly's misty breath adds interest, and the dew drops on the grass and spider's web in the foreground provide a secondary point of interest. Imagine the change in the feel of this painting if I were to paint it in afternoon light.

Painting Weather

When you add elements of weather, such as rain and shadow, don't just add them as part of the environment; use them in the composition. You also can use weather elements to affect the mood of a painting.

ADD TO SUBJECT WITH ATMOSPHERE
I set this painting in heavy rain, creating a mood and adding interest to a painting that would otherwise be mundane in concept. The tiger's expression as it stands in the rain also adds to the feeling of the piece.

MONSOON—WHITE TIGER
24" × 36" (61cm × 91cm) | Acrylic on Masonite | 1991

USE LIGHT AND SHADOW TOGETHER
I set this piece in moonlight, letting the trees' shadows direct the eye. I placed the cougar in shadow so the illuminated snow would become more noticeable as a focal point. In this case the elements that come with the atmosphere contributed to the composition.

MOONSHADOW
24" × 48" (61cm × 122cm) | Acrylic on Masonite | 1997

EVEN DREARY CAN BE INTERESTING

A cold mist shrouds the riverbed on this cold, dank day. The black wolf adds to the dreariness of the environment. Its breath and reflection in the water provide secondary points of interest. Most of the impact, though, comes from the setting and the softly falling snow. Imagine the piece with none of these elements and how uninteresting it would be.

EYES OF WINTER
24" × 36" (61cm × 91cm) | Acrylic on Masonite | 1999

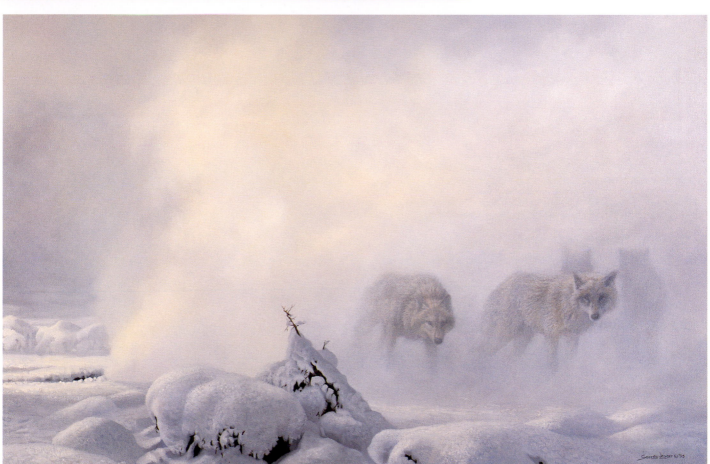

COME OUT INTO THE COLD

In this painting wolves emerge from the steam of a geyser in Yellowstone National Park into freezing air and ice-encrusted snow. I painted the wolves and the plume of steam first. Then I drybrushed a mist over the wolves to push them back. I added shadows in the snow and some dark areas in the foreground for contrast.

RETURN TO YELLOWSTONE
24" × 36" (61cm × 91cm) | Oil on canvas | 1995

Painting Lighting and Atmosphere

Light, as we'll see in chapter eight, affects paintings more than any other element. It can determine the design, value pattern and focal point. Used subtly, though, as backlighting or for an early evening sunset, it also can change the atmosphere of a painting.

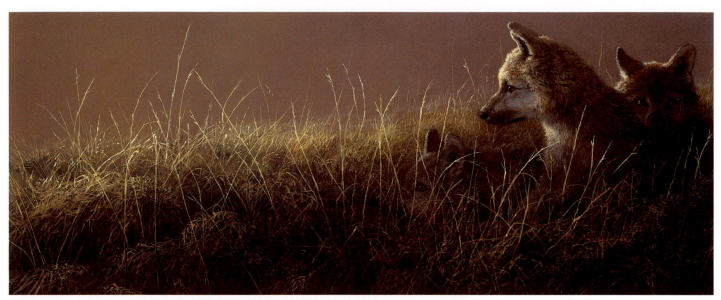

WANING LIGHT

Sundown is always an interesting time to paint. It provides a whole new aura to what otherwise might be uninteresting settings. In this painting I wanted to emphasize a feeling of abandonment; lighting was key.

ABANDONED—WOLF PUPS
15" × 36" (38cm × 91cm) | Acrylic on Masonite | 1993

SUPPLEMENT WITH REFLECTED LIGHT

This is a slightly different concept. A glow emanates from the sun setting behind the jaguar, producing minimal backlighting on the cat. I supplemented the waning backlighting with reflected light.

FOREST GLOW
24" × 36" (61cm × 91cm) | Acrylic on Masonite | 1994

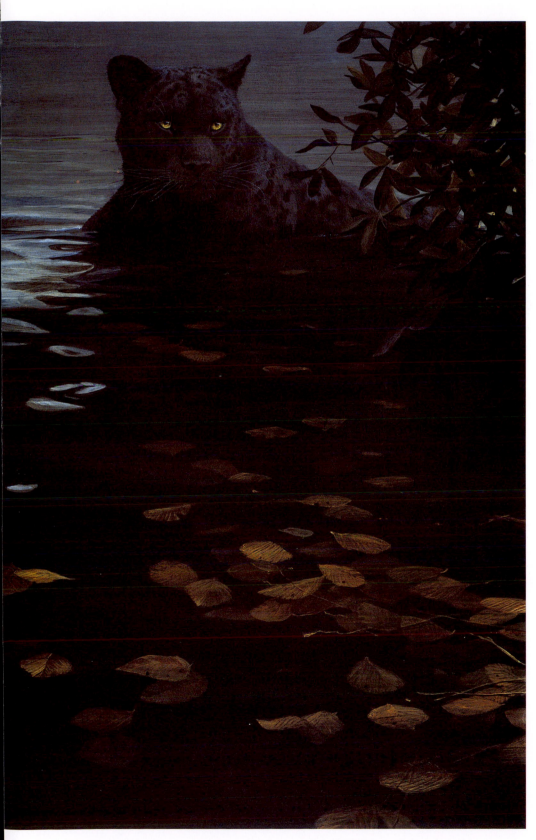

CAPTURE THE CALM OF NIGHT

This is one of my darkest images. I painted this scene as I usually do, painting the cat first, then the foliage and dead leaves, followed by a series of progressively darker washes. The undisturbed water adds to the quiet and stillness of the night.

NIGHT SPECTRE
36" × 24" (91cm × 61cm) | Acrylic on Masonite | 1993

Painting Dark-on-Dark

Dark-on-dark images always have fascinated me. They seem to have an ambiance all their own. The mystery of a dark image is hard to match, especially when the main subject is dark, too. The painting ends up using minimalism to the extreme. Dark images take on many forms. I've done dark images in oil, but I prefer to paint them in acrylic, which allows greater control of the painting when laying in the washes.

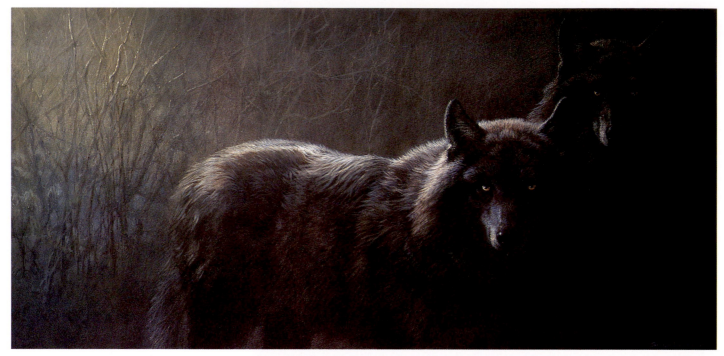

ACCEPT THE CHALLENGE
The challenge of painting such a dark subject appealed to me because the dark-on-dark creates such a dramatic mood. This was one of the first such paintings I did.

BLACK JADE
18" × 36" (46cm × 91cm) | Acrylic on Masonite | 1992

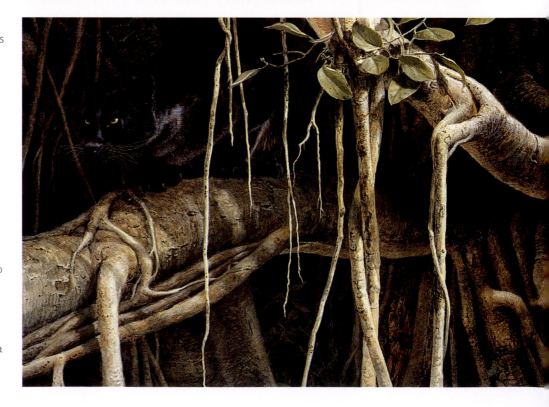

ILLUMINATE DARK SCENES
I pushed the main subject, the leopard, back into the dark shadows, making it a hidden predator. The illuminated banyan tree and foliage become the focal point instead.

BANYAN AMBUSH—BLACK PANTHER
24" × 36" (61cm × 91cm) | Acrylic on Masonite | 1992

CREATE SECONDARY POINT OF INTEREST
I pushed this wolf into the shadow by illuminating the tree and ground cover. Pushing the wolf back adds drama to the piece. I first painted the wolf and background as if in full light, but I kept the background simple because the dark scene wouldn't need detail. Then I pushed the wolf and the background back with a series of washes.

DARK ENCOUNTER—BLACK WOLF
30" × 15" (76cm × 38cm) | Acrylic on Masonite | 1993

Painting Light

We've discussed plenty of factors that can make or break a painting, but light is the single most important aspect of any painting. The basics of light are simple, but putting it to use can be complex. Always remember that light travels in a straight line. If you adhere to this rule in every painting, you can't make a mistake. A cast shadow is darkest near the object being illuminated and fades as it moves away. Light becomes more complex when several light sources emerge, but once you understand the principles and apply them to each light source, you can overcome any of these difficulties.

LIGHT GIVES LIFE

Light drives this painting of a cougar looking into a canyon creek. The intense midday sunlight adds drama and indicates the heat of the scene to the viewer better than any other element could.

HIGH NOON—COUGAR
30" × 20" (76cm × 51cm) | Oil on Masonite | 1991

Lighting Fundamentals

The position of the light source and the position from which the subject is viewed affect the length and perspective of a cast shadow. The angle between the light source and the object dictates the length of the shadow.

CAST SHADOWS

Light travels in a straight line from the light source to the surface it illuminates. If you extend that line to the point at which it would hit the ground, you'll have the length of the cast shadow. The lengths of cast shadows depend not only on how tall the object is, but also on the angle between the light source and the object.

CAST SHADOWS ON VARIOUS OBJECTS

The viewer's perspective of an object affects not only the appearance of the object but also the appearance of the shadow. For more complex objects, such as wildlife, you'll have to draw more cast shadow lines from the light source to the surface to draw an accurate shadow.

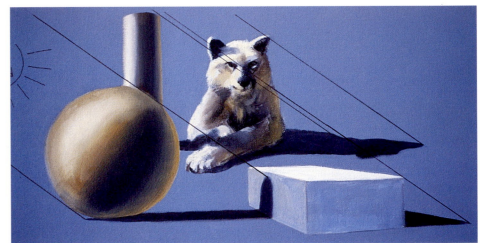

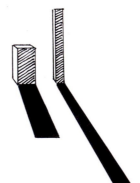

MASTER BACKLIGHTING

Light also travels in a straight line in backlit scenes, although the cast shadows now are coming toward the viewer. Follow the usual principles of perspective to train your eye to see it correctly in backlit settings.

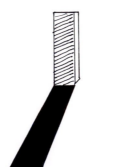

Creating Mood With Light

Light can affect how the viewer sees and feels a painting and how the viewer interprets the subject.

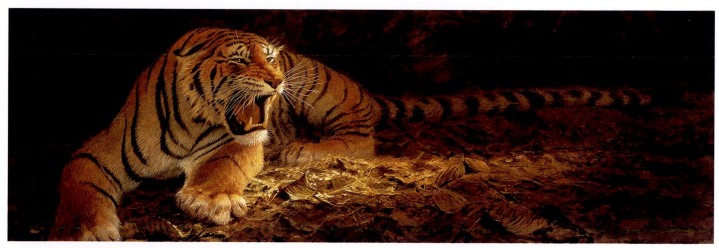

SHARP LIGHT INDICATES ANGER
I emphasized the tiger's fury with my choice of lighting. The light leads the viewer's eyes to focus on the head to create drama. The dark background also adds to the drama.

THE CHALLENGE
12" × 36" (30cm × 91cm) | Acrylic on Masonite | 1997

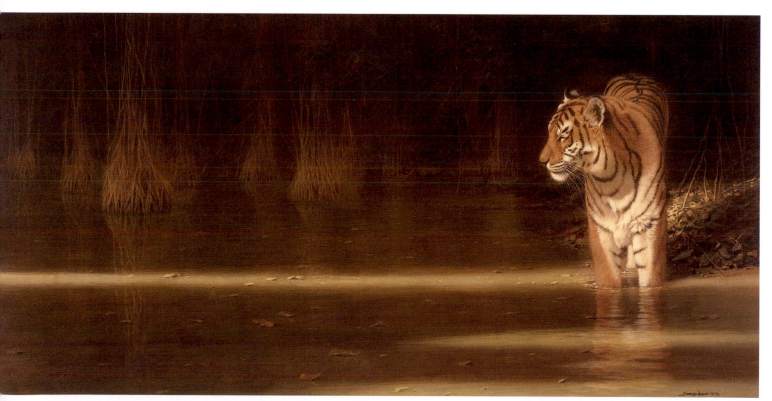

MUTED LIGHT INDICATES PEACE
In contrast to the painting at top, this is a scene of serenity. The light enters at a similar angle, this time offering a feeling of tranquility.

EVENING SOLITUDE
24" × 48" (61cm × 122cm) | Acrylic on Masonite | 1996

Using Light as a Focal Point

Light brings attention to your focal point more than any other element, whether light itself, such as moonlight, or reflected light, such as an animal's eyes, acts as the center of interest.

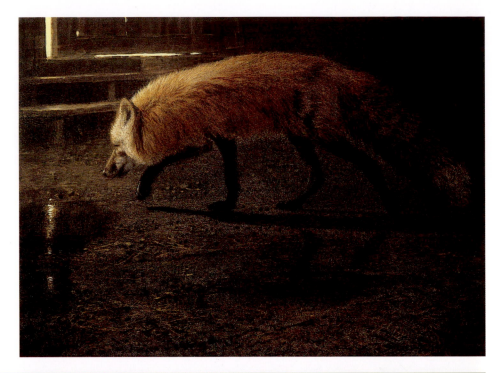

USE TWO LIGHT SOURCES FOR INTEREST

The main light source in this painting is manmade, probably coming from a window. To add interest, I left a door slightly ajar so more light hits the steps and reflects off the puddle.

NIGHT VISITOR
9" × 12" (23cm × 30cm) | Acrylic on Masonite | 1993

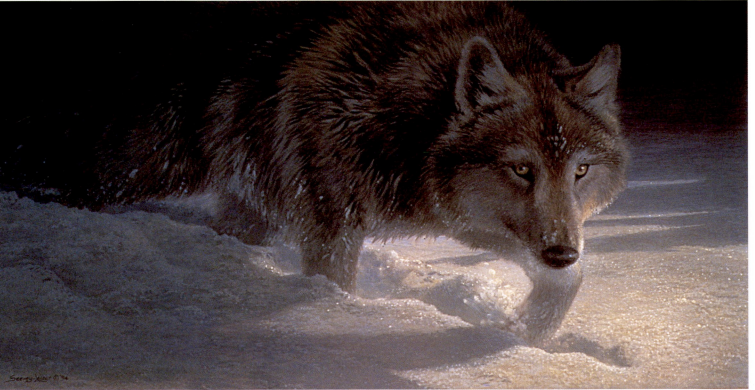

FOCUS ON PART OF SUBJECT

I focused the moonlight on the wolf's head to direct the viewer's eye there. Its body blends into the shadow area.

NIGHT PROWLER—TIMBER WOLF
18" × 36" (46cm × 91cm) | Acrylic on Masonite | 1994

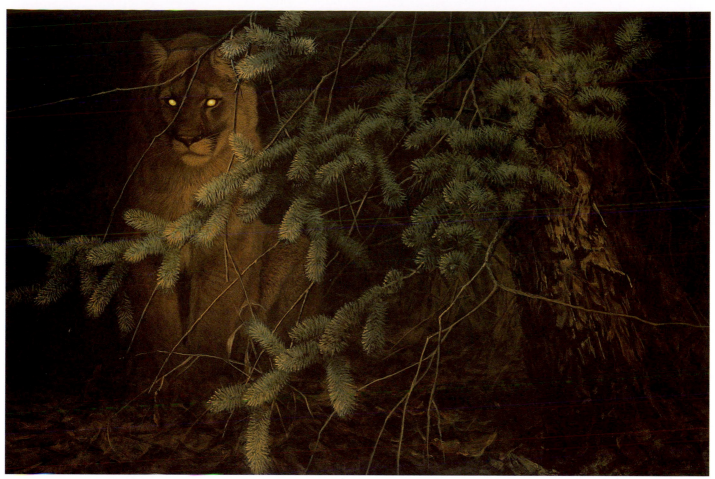

FOCAL POINT CAN BE SMALL
The light source in this painting could come from a campfire or window. The reflected light in the cougar's eyes, no matter what the source, has become the focal point. Imagine the same painting with no reflection in the eyes.

DISTANT LIGHT—COUGAR
24" × 36" (61cm × 91cm) | Acrylic on Masonite | 1999

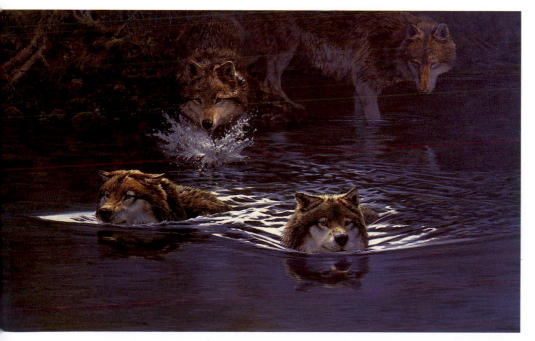

ILLUMINATE AREAS NEAR FOCAL POINT
The light hits not only three of the wolves, but also, and more importantly, the wake in the water. The illuminated water leads the viewer's eye even more strongly toward the wolves. I left one wolf in the shadows and let the moonlight catch the splash of water as another moved from shadow into light.

MOONLIGHT CROSSING
36" × 60" (91cm × 152cm) | Oil on canvas | 1998

Contrasting Light and Dark

The contrast where light meets dark also attracts the viewer's eye strongly. Light meeting shadow and light objects meeting dark objects both do the trick.

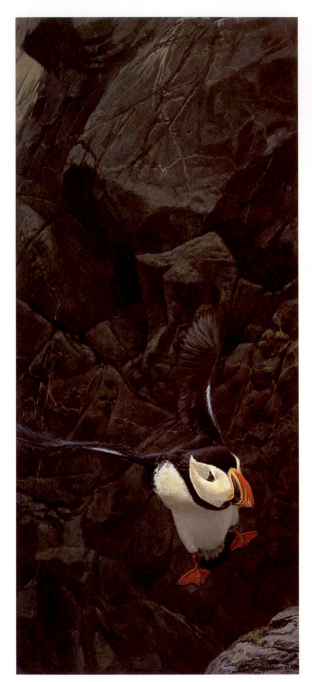

PAINT LIGHT WITHOUT ILLUMINATION

This piece has no strong lighting. Instead it contrasts the dark rocks in the background with the white plumage of the puffin. The only illuminated area is the rock ledge at the very bottom of the painting.

LANDING STAGE
36" × 15" (91cm × 38cm) | Acrylic on Masonite | 1994

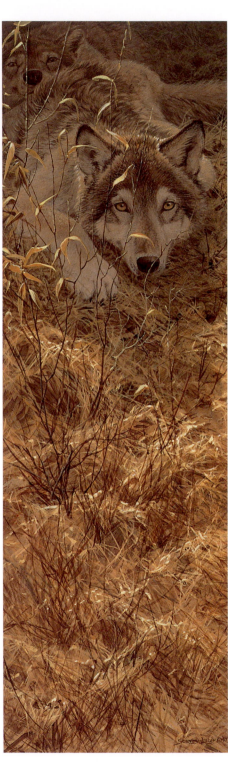

PUSH SUBJECT INTO BACKGROUND

Painters often use contrast to make the subject stand out from the background. In this painting, though, I illuminated the foreground and darkened the background to push it and the wolf pups back.

YOUNG EYES
36" × 12" (91cm × 30cm) | Acrylic on Masonite | 1997

Painting Unusual Lighting Conditions

Use unusual lighting conditions to create impact or make a painting stand out.

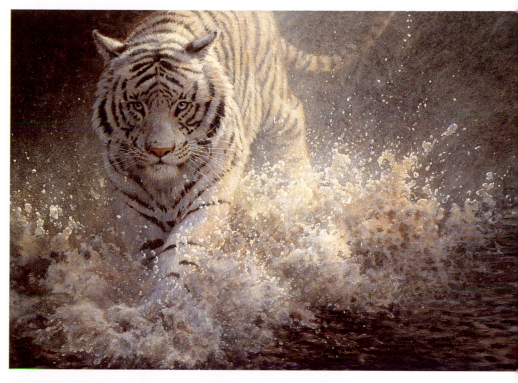

CREATE IMPACT

The light reflecting off both the water and the tiger adds vibrancy to the scene. Again the dark background creates drama. When composing paintings, remember that the point of impact is where dark meets light.

WHITE LIGHTNING
24" × 36" (61cm × 91cm) | Acrylic on canvas | 1997

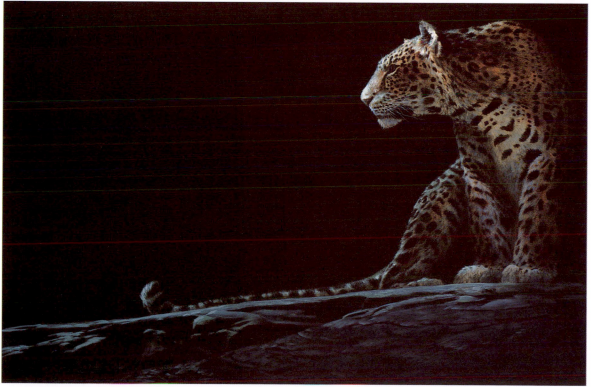

PAINT MOONLIGHT AS SUNLIGHT

I painted this leopard as if in sunlight, then glazed a mixture of Payne's Gray and Ultramarine Blue over the whole painting. Notice how your eye locks into the leopard's face, the brightest part of the painting, which sits next to the darkest part, the black sky.

FULL MOON RISING
24" × 36" (61cm × 91cm) | Oil on canvas | 1999

Playing With Light

These paintings also use light in unusual ways to catch the viewers' interest. *Leopard Walk* uses contrast to put the focal point in silhouette, and *Approaching Fire* uses the light source itself as the focal point.

LIFT LIGHT

In the early stages of this painting, I laid a Burnt Sienna glaze over a canvas panel to provide a warm backlight. Then I laid down a dark glaze of Burnt Sienna and Payne's Gray over the whole painting to establish the darks. I lifted off the water area before the glazes dried, leaving the silhouette of the cat.

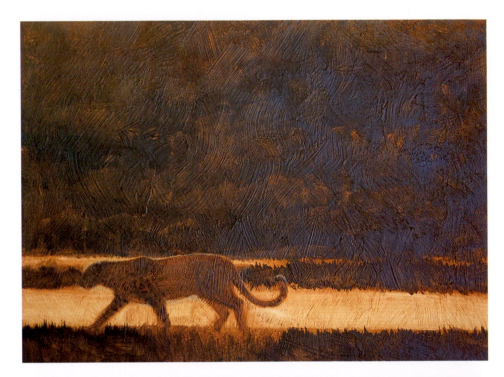

PAINT SILHOUETTE

Using the warm underpainting that I established in the image above, I laid in more detail and emphasized the highlights in the water. Although the cat is in silhouette, it has some backlighting. The success of this piece comes from the almost abstract shape of the light water in contrast to the dark background.

LEOPARD WALK
9" × 12" (23cm × 30cm) | Oil on canvas | 2001

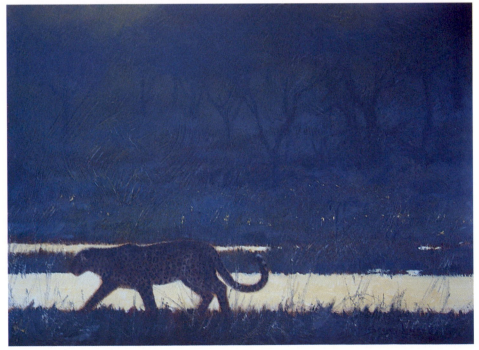

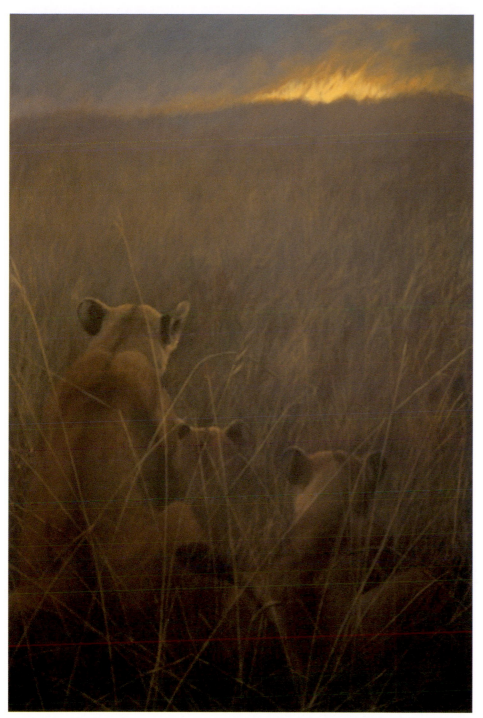

USE LIGHT SOURCE AS FOCAL POINT
Here a single, soft light source appears without really illuminating the scene. It's the focal point of the painting, though. The lions and the savanna grass appear in the shadow, and just a little back-lighting reflects off the cats to bring the viewer's eye to the secondary point of interest.

APPROACHING FIRE
36" × 24" (91cm × 61cm) | Acrylic on canvas | 2001

Backlighting

Whenever you're painting backlighting situation, don't worry about the light source until after you've blocked in the wildlife. The lighting won't change an animal's size or proportion. Once you've blocked in the animal, choose the light source and then paint the details based on that choice.

BLOCK IN FIRST

Light doesn't change an animal's size or proportions, so you can block in the subject before choosing the light source. Once the objects are blocked in, the good lighting choice sometimes will be obvious.

THEN CHOOSE LIGHT SOURCE

I chose to use backlighting to finish this painting. I emphasized the backlighting with the strong light hitting the water. Notice the perspective of the cast shadows from the geese and goslings. Remember that the length of the shadow depends on the height of the light source. In this case, the moon was low in the sky.

LAKESIDE FAMILY—CANADA GEESE
9" × 12" (23cm × 30cm) | Oil on canvas | 1984

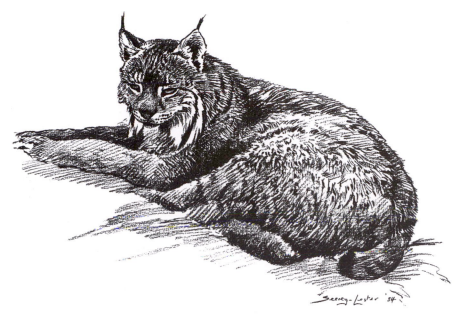

BLOCK IN
I did this simple sketch of a cat in the shade with graphite. I envisioned a final painting with the cat under a tree, but I wanted to do something a bit more dramatic with my use of light.

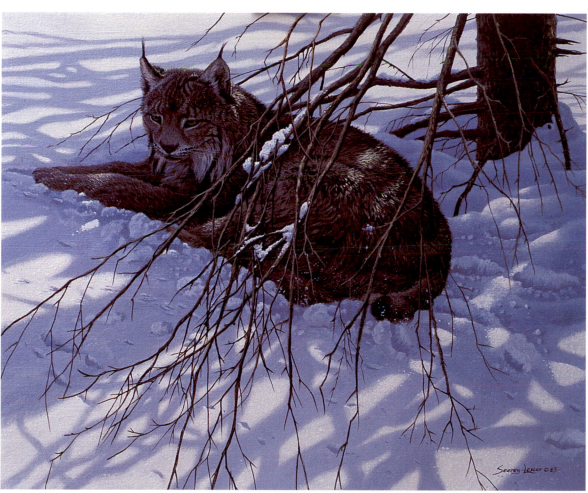

SHADOWS AID COMPOSITION
I decided to use long cast shadows to help the composition. I placed the trunk of the tree at the top right to catch enough backlighting to cast long shadows. I made sure these shadows formed an interesting pattern that leads the viewer's eye through the painting.

WINTER REPOSE—LYNX
16" × 20" (41cm × 51cm) | Oil on canvas | 1985

Using the Light Source Correctly

You don't have to choose the actual light source during the design and composition stage. You can choose any kind of light source that will form the light pattern you want. Pay attention to how that light source will affect perspective and shadows.

EXPERIMENT

If the particular lighting I want to use is tricky or I haven't painted it before, I often do studies of the subject in a few different lighting situations. I decided to use the lighting pattern from this study in a painting.

CHOOSE SETTING

I decided to paint the wolves in a snowy setting, but I still need to choose a light source.

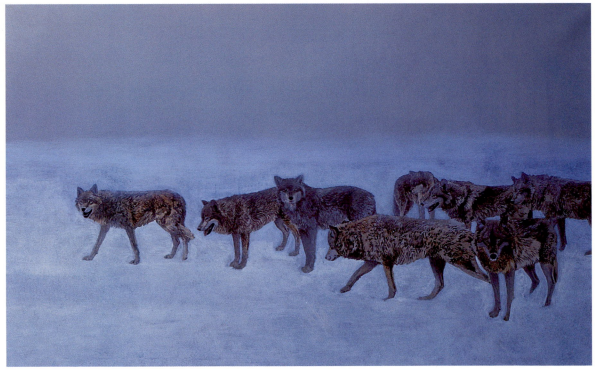

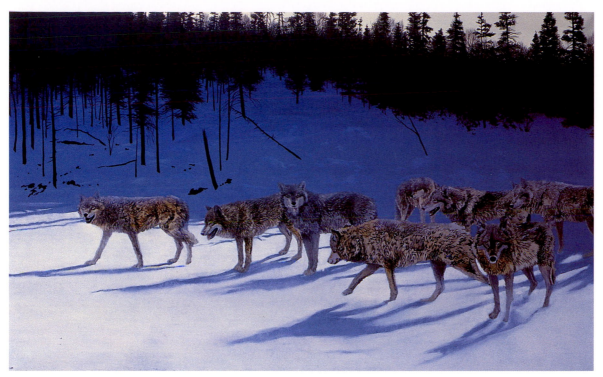

CHOOSE THE LIGHT SOURCE

I chose backlighting and lowered the horizon line so the lighting would work better. Backlighting will place the snow bank in the background in shadow and make the wolves more prominent in the light. Notice that the perspective on the wolves' cast shadows leads the viewer's eye into the piece. I also painted a few cast shadows from the trees in the background.

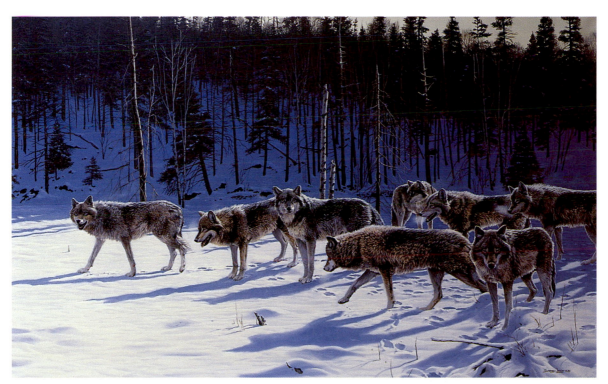

FINISH UP

I intensified the lighting on the wolves, added details to the background, touched up the snow and made sure the perspective on the cast shadows was accurate.

THE GATHERING—GRAY WOLVES
30" × 48" (76cm × 122cm) | Oil on canvas | 1985

Painting a Snowy Sunrise in Oil

This painting, with a white fox and white snow, is very light. The unusual lighting from the sun setting behind the viewer adds the interest that makes the composition work.

1 | BLOCK IN FOX
Block in the arctic fox with a dark, warm mixture of Burnt Sienna and Yellow Ochre. When this is dry, start painting in the background with a no. 14 flat brush and a darker, warm mixture of Ultramarine Blue, Cadmium Red, Titanium White and Payne's Gray.

2 | ESTABLISH LIGHT SOURCE
Finish painting in the background. Now establish your light source. I decided to have the sun set behind the viewer and to the right. Paint over the the underpainting of the fox with a glaze of a mixture of Cadmium Yellow and Cadmium Red.

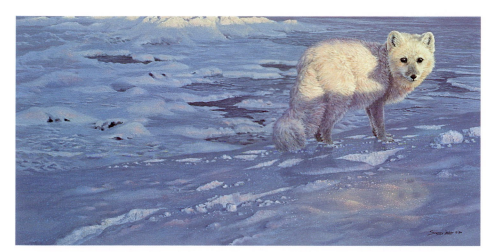

3 | PAINT BACKGROUND

Lay in the background with a no. 14 flat brush. Paint the light areas of the frozen snow with a mixture of Naples Yellow, Flesh Tint and Titanium White. While this is still wet, paint in the shadow areas on the snow with different values of a mixture of Flesh Tint, Ultramarine Blue and Titanium White. Paint the fox with the same mixtures, and thinly glaze the fox's reflection. Paint the small areas of dark water with a mixture of Payne's Gray, Ultramarine Blue and Flesh Tint.

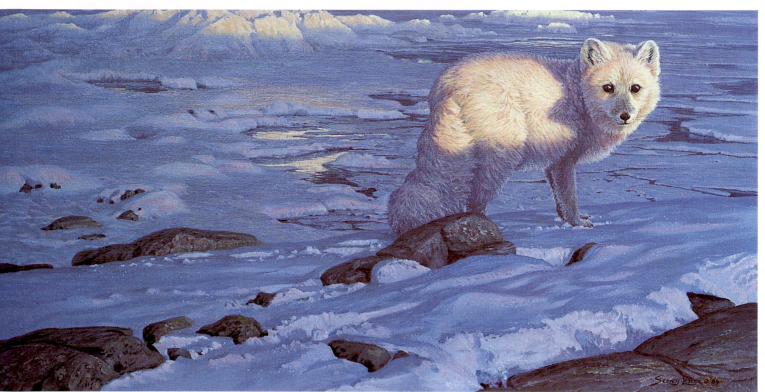

4 | ADD FINISHING TOUCHES

Darken the shadow areas on the snow and the fox by laying in a glaze of Ultramarine Blue and Cadmium Red. Then paint the rocks in the foreground with Ultramarine Blue, Payne's Gray and Burnt Umber. Emphasize the light on the near sides of the snow ridges.

FIRST LIGHT—ARCTIC FOX
15" × 30" (38cm × 76cm) | Oil on Canvas | 1984

Conclusion

This painting was born in the shadow of September 11, 2001, and I hope it will bring hope to those who see it. Those terrible days in New York, Washington, D.C., and Pennsylvania will never be forgotten. In painting I think that where there is darkness there is always light. The same principle applies to life.

Out of the Darkness Into the Light
24" × 48" (61cm × 122cm) | Oil on canvas | 2001

Index

Capture the beauty and power of nature in your paintings!

Make your wildlife paintings stand apart from the herd by capturing the fine details that give your subjects that certain "spark" they need to come to life. Fifty step-by-step demonstrations show you how to make fur look thick, give feathers sheen, create the roughness of antlers and more!

ISBN 1-58180-363-X, paperback, 144 pages, #32331-K

Learn how to create mysterious, atmospheric nature paintings! Whether rendering scales, feathers, sand or fog, dozens of mini-demos and step-by-step guidelines make each step easy. You'll learn to paint the trickiest of details with skill and style. A final, full-size demonstration combining animals with their environment focuses all of these lessons into one dynamic painting.

ISBN 1-58180-050-9, hardcover, 144 pages, #31842-K

Through step-by-step demonstrations and magnificent paintings, Patrick Seslar reveals how to turn oils, watercolors, acrylics or pastels into creatures with fur, feathers or scales. You'll find instructions for researching your subject and its natural habitat, using light and color and capturing realistic animal textures.

ISBN 1-58180-086-X, paperback, 144 pages, #31686-K

Capture your favorite animals up close and personal! Kalon Baughan and Bart Rulon show you how to paint bears, wolves, jaguar, elk, white-tailed deer, foxes, chipmunks, eagles and more, providing invaluable advice for painting realistic anatomy, color and texture in 18 step-by-step demos.

ISBN 0-89134-962-6, hardcover, 128 pages, #31523-K

These books and other fine North Light titles are available from your local art & craft retailer, bookstore, online supplier or by calling 1-800-448-0915.